years of
bauhaus

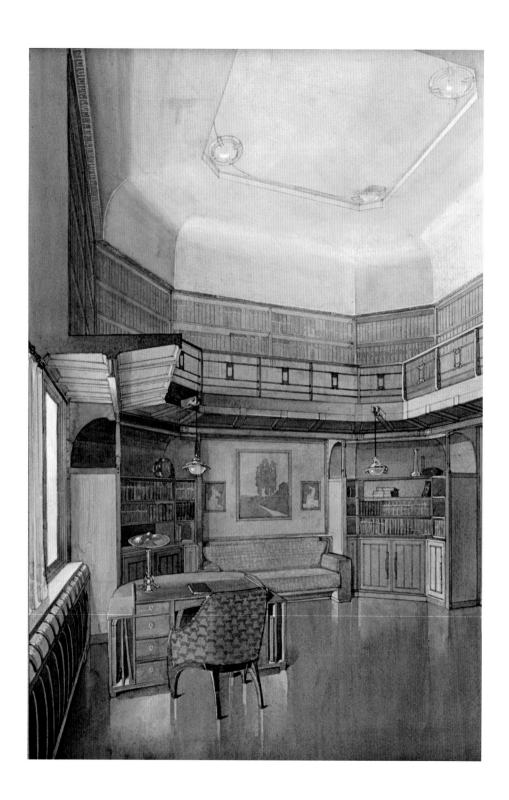

# NEUES MUSEUM WEIMAR

## Van de Velde, Nietzsche and Modernism around 1900

Edited by
Sabine Walter, Thomas Föhl and Wolfgang Holler

With texts by
Ulrike Bestgen, Thomas Föhl, Kilian Jost, Antje Neumann,
Martina Ullrich, Sabine Walter and Gerda Wendermann

HIRMER

KLASSIK
STIFTUNG
WEIMAR

# CONTENTS

# PATHS
# OF MODERNISM

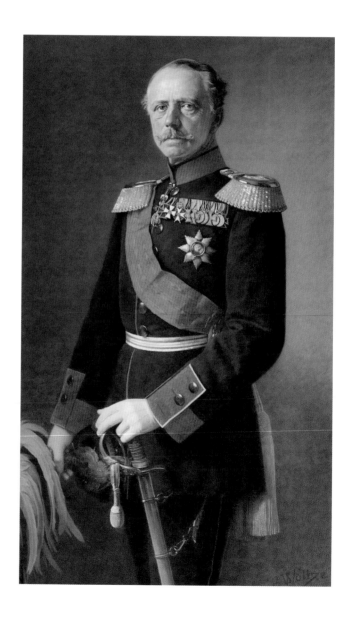

Berthold Woltze,
*Carl Alexander Grand
Duke of Saxony-
Weimar-Eisenach*
(1818–1901), c.1880

**IN 2019 THE NEUE MUSEUM** is celebrating the 150th anniversary of its opening. First inaugurated in Imperial Germany as the Grossherzogliche Museum (Grand Ducal Museum), the building became the Thüringische Landesmuseum (Thuringian State Museum) after the First World War, only to be partly commandeered for non-museum purposes by Fritz Sauckel, the Gauleiter of Thuringia, under National Socialism. Although the damages sustained in the Second World War were reparable, the building was nevertheless abandoned and, in the German Democratic Republic, repeatedly threatened with demolition. In 1999, Weimar's year as the European Capital of Culture, the restored building was returned to the public as a museum and exhibition building for contemporary art and given the name it bears today, the Neue Museum. In recent years, a persuasive and appealing focus was sought, and it is a mixture of serendipity and programmatic choice that the Neue Museum is now, in the context of the modernism debate, dedicated for the long term to developments in art and cultural history from 1860 to 1918. This means that valuable holdings that can no longer be shown in the Stadtschloss (City Palace) due to construction measures can be displayed appropriately and augmented with hidden treasures from the depot with the aim of setting new focal points. The exhibition will also be enriched by many pieces from Manfred Ludewig's top-class design collection, which was donated to the Klassik Stiftung in 2011. Moreover, a number of important acquisitions, particularly of works by Henry van de Velde, are being exhibited for the first time in this presentation.

Of eminent strategic importance for Weimar's museums is the 'topography of modernism', which has been developed with various partners over time. This network under the auspices of the Klassik Stiftung now also links up historic buildings such as the Haus Hohe Pappeln, the Nietzsche-Archiv, the Haus Am Horn and

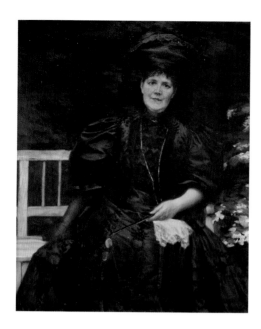

Hans Olde, *Elisabeth Förster-Nietzsche* (1846–1935), 1906

the Liszt-Haus with the Neue Museum and the new Bauhaus Museum Weimar. In the urban setting of Jorge-Semprún-Platz, to the north of the old town centre, this topography condenses into a 'district of modernism'. Grouped around the Gauforum, originally built by the National Socialists and known today as the Thüringer Landesverwaltungsamt (Thuringian State Office of Administration), is not only the newly constructed Bauhaus Museum, the Neue Museum, the Stadtmuseum (City Museum) or the Weimarhalle event building with its park and sports grounds, a cultural project dating from the Weimar Republic. The ensemble also includes the installation *Concert for Buchenwald* by Rebecca Horn and, in the future, an exhibition sponsored by the Buchenwald and Mittelbau-Dora Memorial Foundation about Nazi forced labour, as well as the updated exhibition on the Gauforum during the years of National Socialism. Closer to the city centre, the district extends to the Haus der Weimarer Republik – Forum für Demokratie (House of the Weimar Republic – Forum for Democracy) at Theaterplatz.

With its new orientation, the Neue Museum will be a central exponent of this exciting interplay by addressing the important

chapter that preceded the Bauhaus and the Weimar Republic, without which the development of the twentieth century's most significant school of design would not be comprehensible. Hence, the thematic coordination with the Bauhaus Museum is especially close. A pivotal exhibit in this regard is the bookbinding workshop of Otto Dorfner, for instance, which is being displayed at the Neue Museum. Dorfner was appointed to the Grossherzoglich Sächsische Kunstgewerbe-schule Weimar (Grand Ducal Saxon School of Arts and Crafts) by Henry van de Velde, worked for Count Harry Kessler and taught at the Bauhaus until 1922.

The central idea of integrating the Neue Museum into a 'district of modernism' is to accentuate Weimar's exemplary role in the modernism debate in the late nineteenth and the twentieth centuries, and to present and communicate it effectively to the public. Here, questions will be posed about the persistence of traditions, the contemplation of the future, the image of man, ways of living and forms of society that time and again take concrete shape in a particular living environment. In relation to art and culture, at the Neue Museum this means examining the emergence of avant-gardism among the Weimar school of painting and exploring the freedom enjoyed at the Grossherzogliche Kunstschule Weimar (Grand Ducal Saxon Art School),

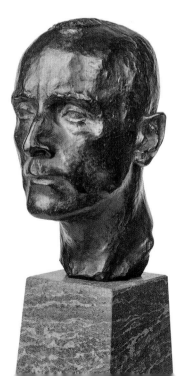

Georg Kolbe, *Count Harry Kessler* (1868-1937), 1916 (replica 2018)

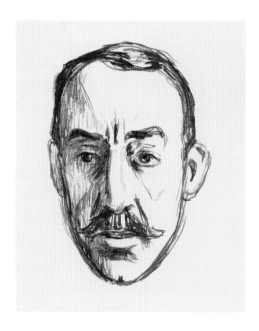

Edvard Munch,
*Henry van de Velde*
(1863–1957), c.1906

founded in 1860. Those years of Weimar's 'silver age' are essentially bound up with the culture advocate Grand Duke Carl Alexander, who is therefore presented as the first leading figure.

The period around 1900 merits special attention, for in the few years before and after the turn of the century an attempt was made to establish an entirely new Weimar, a Weimar that strove to implement a fundamental reform of life through culture. Elisabeth Förster-Nietzsche and Count Kessler were the most prominent individuals here. Kessler's time saw pioneering exhibitions of Impressionist and Neo-Impressionist artists; acquisitions of works by Auguste Rodin, Théo van Rysselberghe and Claude Monet; the building and remodelling of the Grand Ducal Saxon Art School and the founding of the Deutsche Künstlerbund (Association of German Artists), the umbrella organisation of the secessions and the antithesis of the staid Allgemeine Deutsche Kunstgenossenschaft (General German Art Cooperative).

How strongly all of this ties into an internationally new understanding of art, the handicrafts and architecture, and moreover, how great a role economic and educational considerations played in the

matter, is made abundantly clear by the example of the 'all-round artist' Henry van de Velde. This central figure of the exhibition was active in Weimar from 1902 and, despite resistance from many quarters, excelled creatively during this period. A committed teacher, he founded the Kunstgewerbliche Seminar (Arts and Crafts Seminar), which was succeeded in 1908 by the Grossherzoglich Sächsische Kunstgewerbeschule Weimar, the direct forerunner of the Staatliche Bauhaus Weimar (Weimar State Bauhaus). With regard to van de Velde, questions about the social context come especially to the fore: who were his customers, for instance, how much did his works cost, and who manufactured them? The First World War – in no small part a 'war of minds' in which, according to the propaganda, a profound Germanic culture was supposed to assert itself against the shallowness of Western civilisation – caused a catastrophic caesura and laid waste to the Imperial German world. Many achievements of this bygone era nevertheless became part of the continuing development of modernism. 'Modernism' must therefore always be understood in the context of its historical mutability, its diversity of form, its ambivalences, continuities and disjunctures. The fact that, for instance, certain ideologically progressive attitudes can also be radically misused is demonstrated by the shifting understanding of 'the new man', which is closely associated with Friedrich Nietzsche. His doctrine of the *Wille zur Macht* (will to power) that was to take concrete shape in the *Übermensch* (superior human being) was interpreted in radical nationalist circles, and later by the National Socialists, not as the will to capability, to enrichment or conquest of the self, but as a call for the dominance of one 'master race' over another.

Thus, many questions from this bygone age remain as relevant as ever and tie Weimar into an encompassing perspective. Ultimately, the quest today is, just as it was then, to seek out the intrinsic 'fluid of life' (Walter Gropius) and lend it convincing form in art and design.

WOLFGANG HOLLER

General Director of Museums
Klassik Stiftung Weimar

# A MUSEUM MAKES HISTORY

## From the Grand Ducal Museum to the Neue Museum Weimar

KILIAN JOST

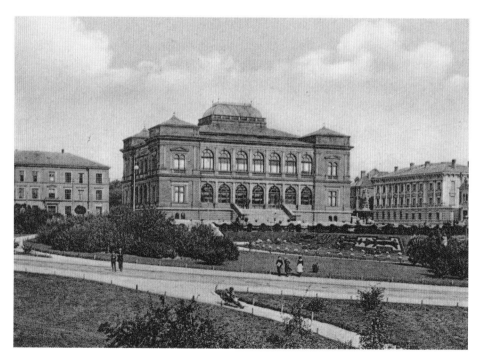

The Grossherzogliche Museum on Karl-August-Platz, view from the south-west, c.1900

LIKE MUCH ELSE IN WEIMAR, the idea for a museum can be traced back to Johann Wolfgang von Goethe. It was he who, in 1809, advocated the benefits of a public exhibition of artworks from the ducal collection. That same year, the Fürstliche freie Zeichenschule Weimar (Weimar Princely Free Drawing School) put works from the ducal collections on display as study material and exemplary models in its rooms in the Fürstenhaus. In the palace's great hall and, for a short time, in the large hunting lodge, the art collections remained publicly accessible until 1848. A museum building of its own only became a reality at the initiative of Grand Duke Carl Alexander. In 1858 he pronounced an 'art credo', a programme for patronage of the fine arts in the grand duchy. This would reach its apotheosis in the construction of a museum of national standing. The designs submitted by the Prague architect Josef Zítek in 1862 comprised ideas for two buildings: the Prellergalerie and the museum building to house the grand ducal art collections. Its designated site, on the axis between the train station and the old town centre, was intended to upgrade the infrastructure of Weimar's nascent northern suburb.

The opening of the Grossherzogliche Museum (Grand Ducal Museum) took place in the summer of 1869. Along with casts taken from ancient sculptures as well as paintings by the Old Masters and Neoclassical art, it also displayed the Sample Collection of Architecture and the Arts and Crafts. Count Harry Kessler organised the third exhibition of the Deutsche Künstlerbund (Association of German Artists) here in 1906. Alterations to the building planned by Henry van de Velde in 1907 and 1908 remained unrealised. Confined to the interior spaces, his designs show purified, elegant room settings with little or no embellishment.

From 1918 onwards, following a reorganisation of the grand ducal art collections, the building – by now renamed the Thüringische

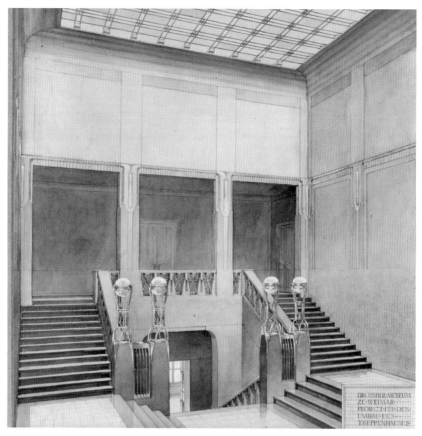

Henry van de Velde, Design for the modification of the Grossherzogliche Museum, staircase, 1908

Landesmuseum (Thuringian State Museum) – housed the art of the late nineteenth century and particularly the Weimar school of painting. The new director Wilhelm Köhler showed the work of controversial avant-garde artists in monthly rotating exhibitions, beginning in 1921. Apart from Edvard Munch, these included Alexej von Jawlensky, Johannes Molzahn, Walter Dexel and Theo van Doesburg, along with such German Expressionists as Ernst Ludwig Kirchner, August Macke, Erich Heckel and Emil Nolde. The International Congress of Constructivists and Dadaists visited the museum in 1922. In the same year, the Bauhaus masters Lyonel Feininger, Wassily Kandinsky, Georg Muche and Paul Klee took part in the *Erste Thüringer*

*Kunstausstellung* (First Thuringia Art Exhibition). A further presentation of the Bauhaus masters' art took place under the auspices of the Bauhaus exhibition of 1923, this time also including works by László Moholy-Nagy, Gerhard Marcks and Oskar Schlemmer as well as the students Johannes Driesch, Marcel Breuer, Rudolf Baschant and Paul Citroen. Schlemmer supplied colour proposals for the rooms of the museum, but the bolder colour scheme of his student Hinnerk Scheper was the one implemented. As late as 1930, former students such as Thilo Schoder, Driesch and Max Merker were still being given solo exhibitions.

In 1933 the Reich Governor's office was installed in the museum's east wing, and its expansion in the following years increasingly constrained the use of the museum. Until 1937 Gauleiter Fritz Sauckel had his headquarters in the south-eastern corner pavilion and oversaw the planning of the Gauforum from 1935 onwards. The location had been suggested by Paul Schultze-Naumburg. When construction commenced in 1937, the generous parklands in front of the museum were destroyed. Hermann Giesler's plans integrated the

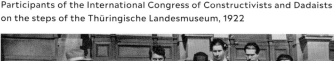

Participants of the International Congress of Constructivists and Dadaists on the steps of the Thüringische Landesmuseum, 1922

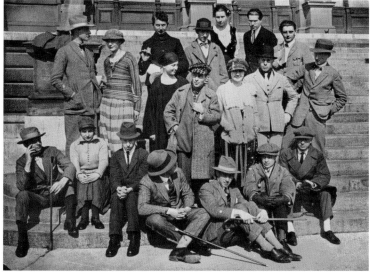

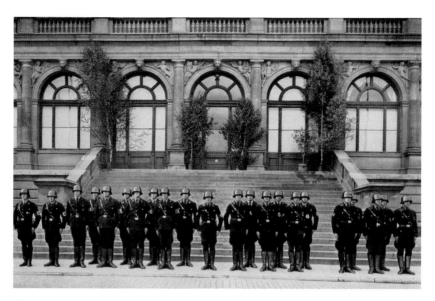

SS guard corps in front of the Reich Governor's office at the
Thüringische Landesmuseum, 1934

museum but effectively compromised it. In the Second World War, three bombing raids wrought heavy damage on the museum. Nevertheless, shows such as the 1946 *Thüringische Kunstausstellung* took place until 1949. Neglect of the building thereafter led to its increasing dereliction. Despite being recognised as an architectural monument in 1952, the building was repeatedly threatened with demolition. Only in the spring of 1989 did a community action group begin to clear the ruins. Structural stabilisation and reconstruction work, with the cooperation of the Weimar art collections, were completed in 1998.

The museum's reopening as the Neue Museum Weimar was celebrated in 1999 when Weimar was the designated European Capital of Culture with the show of contemporary art from the Paul Maenz collection. On the centenary of the founding of the Staatliche Bauhaus Weimar (Weimar State Bauhaus), the permanent exhibition *Van de Velde, Nietzsche and Modernism around 1900* now commemorates the institution's historical antecedents.

The staircase in the Landesmuseum, 1985

# Friedrich Preller the Elder
## *Odysseus and the Sirens*, 1868

Excerpt of the 16-part *Odyssey* cycle in the Prellergallerie
at the Neue Museum Weimar

The Prellergalerie, along with the statue of
Johann Wolfgang von Goethe by Carl Steinhäuser
and the murals designed by Daniel Buren, Sol
LeWitt and Robert Barry, is part and parcel of the
interior of the Neue Museum and closely linked
with the building's history. In 1858 the most
highly esteemed painter in the city and grand
ducal seat of Weimar, Friedrich Preller the Elder,
had presented much-admired designs for a series
of images based on Homer's *Odyssey*. Grand Duke
Carl Alexander thereupon commissioned him with
a series of large-format wall paintings, which were
to be shown in an open hall. While on a study visit
to Italy made in preparation for this commission,
Preller made the acquaintance of architect Josef
Zítek, who delivered the first designs for the
single-storey hall in 1861. These plans ultimately
coalesced with the idea of a museum building.
Preller did not execute the work as a fresco on
site, but in encaustic painting on transportable
limestone slabs in his studio. After completion,
these were set into the wall recesses that had
been created to receive them. In six scenes they
depict Odysseus' voyage from his departure from
Troy to his homecoming to Ithaca. KJ

# TUMULT OF STYLES
## Carl Alexander between industrialisation and historicism

GERDA WENDERMANN

Hugo von Ritgen (design), Couch from
the Neue Kemenate at the Wartburg,
1858–59, Friedrich Hrdina (execution),
permanent loan from the Wartburg-
Stiftung Eisenach

**IN LIGHT OF THE ENORMOUS** social and scientific revolutions which had sparked rapid industrialisation throughout Europe, nineteenth-century contemporaries had an ambivalent relationship to history. On the one hand, the world expositions, the first of which was staged in London in 1855 as a 'peaceful competition between nations', called for an optimistic and open-minded attitude towards the future. Yet on the other hand, society felt threatened by the far-reaching changes that technology had unleashed. The growing web of international relations resulted in a search for one's national roots. It produced a dialectic of movement and stagnation, technical revolution and aesthetic conservatism. It was in this context that the phenomenon of historicism took hold – a time when epochal styles of history, such as Romanesque, Gothic, Renaissance, Baroque and Rococo, offered intellectual and ideational possibilities of orientation. Thus, modern technologies such as cast-iron and glass constructions were initially proudly presented, only to later disappear behind the pomp of historical architecture.

Carl Alexander, who assumed regency of the Grand Duchy of Saxony-Weimar-Eisenach in 1853, was confronted with these same challenges. As an enlightened heir in a long line of Ernestine art patrons, he cultivated an image of himself as an advocate of the fine arts. However, he soon recognised the need to industrialise the largely agrarian economy of his micro-state. The engine of industrial progress was the expansion of the railroad, which benefited not only Jena, Neustadt/Orla and Eisenach but also Apolda. Contemporaries had even praised the town as the 'Thuringian Manchester'.

In response to the inferior quality of goods produced by the duchy's manufacturing sector, Carl Alexander took a special interest in developing the arts and crafts. Since being named an honorary member of the Munich Association for the Education of the Trades in

The Grossherzogliche Museum, Eastern Column Hall with the Sample Collection of
Architecture and the Arts and Crafts, c.1890

1851, which enjoyed the patronage of King Maximilian II of Bavaria,
the Hereditary Grand Duke Carl Alexander began supporting the
Weimar Trades Association. He was interested in the goals of the
English art theorist John Ruskin and the Arts and Crafts movement,
which influenced his own ideas on the fruitful relationship between
the arts and handicrafts. In fact, the initial plans for his new Gross-
herzogliche Museum (Grand Ducal Museum) included an arts and
crafts museum based on the model of the South Kensington Museum
in London. Although they failed to materialise due to financial rea-
sons, when the Weimar museum finally opened in 1869, it included
not only casts of ancient statues as well as paintings and sculptures
from the Renaissance to the Neoclassical era, but also a Sample Col-
lection of Architecture and the Arts and Crafts in the hall of the east
wing and the adjacent corner pavilion on the first floor. The collection
comprised ancient Greek vases, Italian majolica, items from the old
art and curiosity cabinets, and historical glass works. Most of these
art treasures were owned by the grand duchy and supplemented by
pieces purchased by the collector Carl Stegmann, for the sample

collection of arts and crafts. The corner pavilion, on the other hand, presented an 'exhibition of modern arts and crafts products'. These included not only such items as the Neo-Baroque glassware by the Venetian glass manufactory Salviati, which the Weimarer Gewerbe-verein purchased at the Parisian World Exposition of 1867 and provided to the museum as a permanent loan, but also the latest products manufactured by regional merchants.

This extensive collection was explicitly intended to serve as a model from which all tradespeople could learn and improve the quality of their own work. In order to attract national attention to these developments in Thuringia, several outstanding items from the exhibition were sent at Carl Alexander's request to the *2. Kunst- und Kunstgewerbeausstellung* (Second Arts and Crafts Exhibition), in Munich in 1876. The establishment of the Grossherzoglich

Amphora-shaped vase, Germany, c.1880.

Glass vase with threading, Società Salviati & Co., Venice, 1850–80

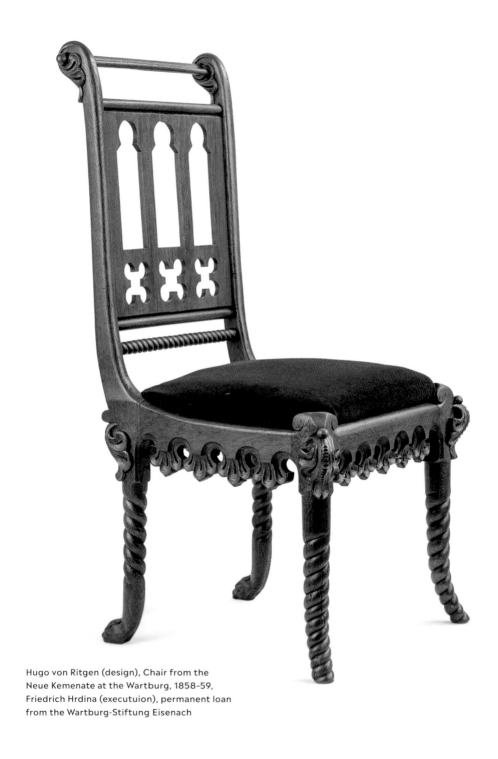

Hugo von Ritgen (design), Chair from the
Neue Kemenate at the Wartburg, 1858–59,
Friedrich Hrdina (executuion), permanent loan
from the Wartburg-Stiftung Eisenach

Nautilus goblet, Töpfermanufaktur Franz Eberstein, Bürgel, 1900, permanent loan from the Keramik-Museum Bürgel

Amphora-shaped vase, Tonwarenfabrik Carl Albert Schack, Bürgel, 1880–90

Sächsische Zentralstelle für Kunstgewerbe (Grand Ducal Saxon Central Office for Arts and Crafts) in Weimar in 1881, headed by the architect Bruno Eelbo, was another measure that served to promote the arts and crafts in the duchy. Eelbo offered advice to long-established companies like the court cabinetmaker Scheidemantel and the court potter Schmidt, whose kiln factory was one of the most important in Thuringia. Eelbo's clients included the ceramics workshops in Bürgel that were struggling against overwhelming competition from mass-produced crockery made of stoneware, porcelain and tin. Instead of relying solely on items made on the potter's wheel, manufacturing companies, such as those operated by Hermann Schauer, Carl Albert Schack and Carl Gebauer, began adopting new casting processes with

the aid of plaster moulds and templates, which enabled them to produce larger batches. Using pattern books available at the time, they oriented their designs on models of ancient vases, medieval beer mugs and Baroque bowls. With their opulent ornamentation, these historicist ceramics matched the prestigious taste of middle-class society and decorated their opulently furnished *Gründerzeit* salons. Although many of these were early examples of serial production, the flexible use of applications and top glazing allowed for a wealth of diversity.

In line with the Romantic-era rediscovery of the Middle Ages, Carl Alexander announced his plans to rebuild the Wartburg beginning in the 1840s. As a national monument,

the fortress would politically reinforce the historical significance of the Ernestine dynasty as a patron of the arts and the Reformation. The large-scale project aimed at achieving a 'total effect', not only with its impressive architecture but also with paintings, sculptures and corresponding furniture and interior furnishings. In 1849 the architect Hugo von Ritgen was appointed to oversee the reconstruction of the fortress, partly as a museum restored according to landmark conservational aspects, and partly as a residence for the grand ducal family. The rooms were decorated with a combination of original and historicist objects, for which Ritgen provided the designs. Upon the express request of Carl Alexander, the Neo-Romanesque-style furniture was manufactured by regional workshops. In order to create a medieval-themed *Gesamtkunstwerk*, Carl Alexander commissioned – on the recommendation of his artistic counsellor and Hofkapellmeister Franz Liszt – the well-known Munich artist

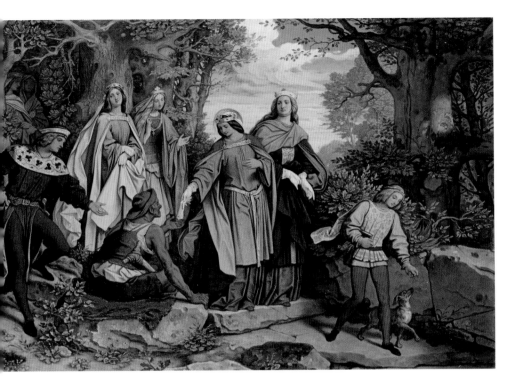

Moritz Schwind, *The Glove of Saint Elisabeth*, 1856

Moritz von Schwind to paint a series of murals depicting the legend of St Elisabeth and the central *Sängerkrieg* (minstrel contest) fresco. History painters at the Grossherzogliche Kunstschule Weimar (Grand Ducal Saxon Art School) likewise received commissions to produce a series of paintings on Luther's life for the Reformation Rooms in the Wartburg.

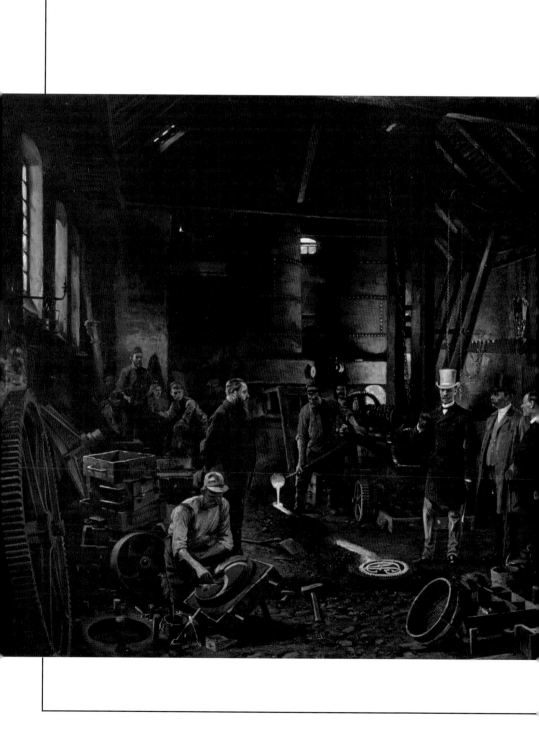

# Hans W. Schmidt

## *Grand Duke Carl Alexander of Saxony-Weimar-Eisenach at the Stieberitz Iron Foundry in Apolda*, 1889

Permanent loan from HH Princess Leonie of Saxony-Weimar-Eisenach

The regent between the arts, crafts and industry – no other picture better expresses the ambivalence of this relationship than this work by the history painter Hans W. Schmidt. The portrait documents the grand duke's visit to one of the largest metalworking companies in Apolda in 1889, which produced steam engines and boilers as well as cast-iron spiral staircases and pillars. Carl Alexander, donning gloves and a bright top hat and posing in an aristocratic fashion, watches as a gear wheel with his initials CA is poured while an official and the company owner explain the process to him. In contrast to this well-dressed group of middle-class onlookers, the hard and filthy toil is unmistakeably reflected in the portrayal of the foundry workers. GW

# OUT INTO NATURE!

## From the Weimar Art School to the school of painting

GERDA WENDERMANN

Paul Baum, *Path to Niedergrunstedt*, 1886

**THE GROSSHERZOGLICH SÄCHSISCHE** Kunstschule (Grand Ducal Saxon Art School) was founded in 1860 by Grand Duke Carl Alexander and financed from his private coffers. From its inception the institution differed in many ways from academies elsewhere in Germany, which were older and more hidebound by tradition, because at Carl Alexander's insistence, the liberal principle of the freedom of art prevailed. His ambition was to attract the renowned artists of the day to Weimar in order to restore his ducal seat as a centre of German intellectual and cultural life, as it had been during its classical heyday around 1800.

As director the grand duke appointed Stanislaus Graf von Kalckreuth, who had studied under Johann Wilhelm Schirmer at the Kunstakademie Düsseldorf (Düsseldorf Art Academy) and was a landscape painter. He considered the study of antiquity a much lower priority than the study and experience of nature, which he made the focal point of training. From the very start, Kalckreuth placed his faith in such talents as Arnold Böcklin, Franz Lenbach and Alexander Michelis, artists whose new naturalist view of the landscape made them a counter-force to the late Neoclassical, idealistic landscape painting of which Friedrich Preller the Elder was Weimar's main exponent. At the same time, he ensured that in the statutes of the art school and its internal structure, landscape as a subject of instruction was ascribed the same status as the history and genre painting that dominated the German academies in his day. This was a remarkable innovation, which spoke volumes about the progressiveness of the Weimar training establishment, and also attracted young artists, including Max Liebermann, from not only all corners of the German Empire but also England and the United States. Again at Carl Alexander's behest, history painting was taught by renowned Belgian artists such as Ferdinand Pauwels, Alexandre Struys and Willem Linnig.

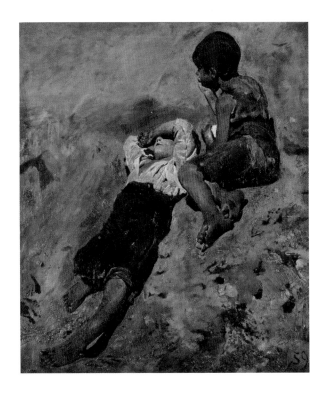

Franz von Lenbach,
*Italian Boys*, 1859

A decisive change in the art school's direction came at the beginning of the 1870s with the appointment of Theodor Hagen, another landscape painter rooted in the tradition of the Düsseldorf school of painting. In Weimar he became a substantial 'developer of individuals', who encouraged such students as Ludwig von Gleichen-Russwurm, Paul Baum, Hans Peter Feddersen, Franz Bunke and Christian Rohlfs to develop their artistic faculties to the full. Hagen's arrival also meant that Weimar was very early to engage with the realistic *plein-air* painting of the French masters of the Barbizon school. Unconfined by the strict rules of the Parisian academy, since the 1840s the village of Barbizon near the forest of Fontainebleau had become a popular gathering place for painters. Thanks to novel, industrially manufactured colours in tubes and portable easels, they could paint directly from their motifs in the open air and no longer had to compose their pictures in the studio from individual sketches. Among the first artists who sought to depict the atmospheric and

Theodor Hagen, *In the Dunes of Scheveningen*, 1876

Max Liebermann, *Woman Gathering Potatoes*, 1874

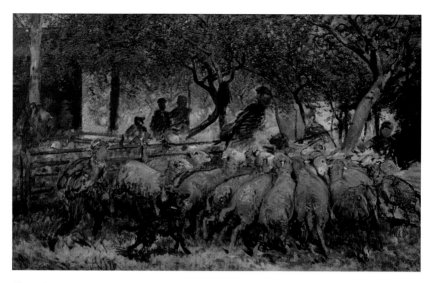

Albert Brendel, *Sheep Market near Weimar*, c.1880

ever-changing faces of nature in France were Camille Corot, Gustave Courbet, Théodore Rousseau and Jean-François Millet.

In Weimar the preference for *plein-air* painting was reinforced by the appointment of the Berlin animal painter Albert Brendel, in 1875. Brendel was among the most significant early German proponents of the new landscape painting. From 1854 he stayed regularly in Barbizon and maintained friendly relations especially with the French animal painters Constant Troyon and Charles Emile Jacque. He made his extensive collection of early nature photographs and reproductions of paintings by the Barbizon masters available to the Weimar students as source material for instruction and contemplation.

Hence, by the end of the 1870s, a group of artists emerged in the immediate vicinity of the art school who had turned their backs on motifs of Weimar Classicism specifically in order to seek out the 'true', the 'natural' and the 'simple' in Thuringia's hilly landscape and rural way of life. The signs of industrialisation, expanding railways, or factories with smoke billowing from chimneys were consequently excluded as motifs. This loose grouping included Karl Buchholz, Gleichen-Russwurm, Baum, Eduard Weichberger, Paul Tübbecke,

Bunke, Feddersen, Carl Arp and Rohlfs. Referred to from an early stage as the Weimar Malerschule (Weimar school of painting), they developed a characteristic preference for the unsentimental melancholy of austere late-autumnal and early-spring landscapes as well as a grey-toned colour palette that earned it the sobriquet 'the grey school'. Unlike other groups of artists, such as those in Düsseldorf or Munich, they felt no need to found an artists' colony in the countryside because their motifs – stark forest interiors, village views or broad harvest landscapes – could be found in and around Weimar itself. For study purposes, Gleichen-Russwurm nevertheless travelled to Barbizon, while Baum visited the Netherlands to see the works of the Hague school, which likewise propounded progressive *plein-air* painting. Numerous Weimar artists were also drawn to the artists' colony in Dachau.

Eduard Weichberger, *Barn with Birches*, c.1865

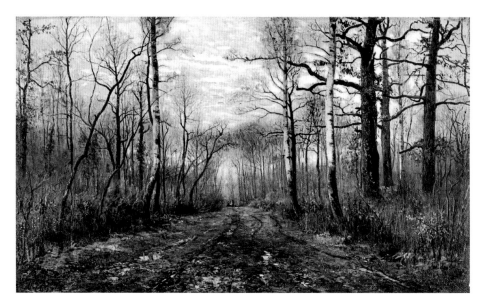

Karl Buchholz, *Inside the Forest – Spring in the Webicht Landscape*, c.1880

The main artist figure of this early period is Buchholz, who chose the Webicht, the light beech woodland between Weimar and Tiefurt – evoking the famed model of the forest of Fontainebleau – as his preferred motif. Characteristic of his small-format, 'intimate' paintings is a mood that is unmistakably melancholy without arousing sentimentality. Buchholz's subtly nuanced painting style sought to depict the silhouette-like effect of the bare trees in early spring and late autumn, and thus became a seminal influence on the Weimar school. By contrast, from the late 1880s onwards, Rohlfs favoured the old, overgrown embankments in the south of Weimar. He developed an autonomous expressive painting style and thereby pre-empted developments in art that were to follow later.

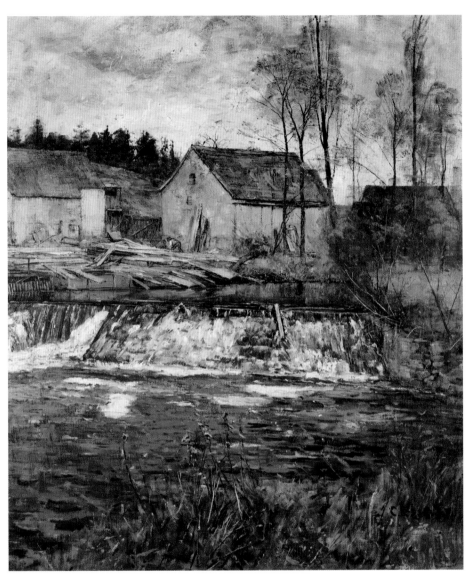

Christian Rohlfs, *Sawmill on the Ilm in Ehringsdorf*, 1883

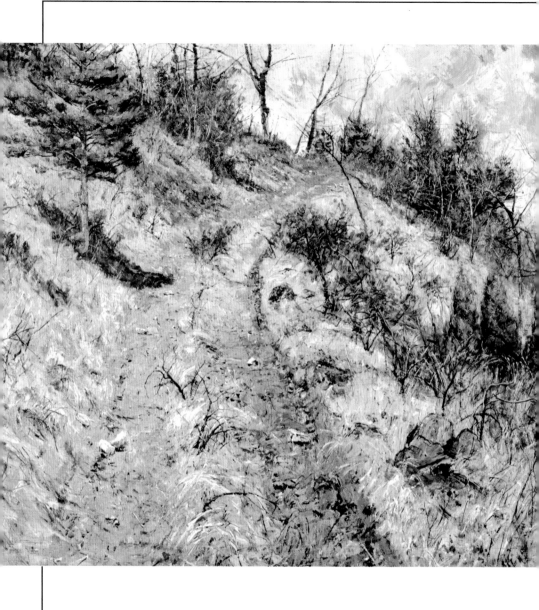

**Christian Rohlfs**

*Scarp Slope in March, c.1889*

With his lively spatula and brush technique and relief-like impasto application of paint, Christian Rohlfs endowed the unspectacular motif with an impressive presence, which is further accentuated by the observer's low-lying vantage point and the size of the picture. GW

# 'I DON'T WANT ANY "WORSHIPPERS"'

## The cult around Friedrich Nietzsche

ULRIKE BESTGEN

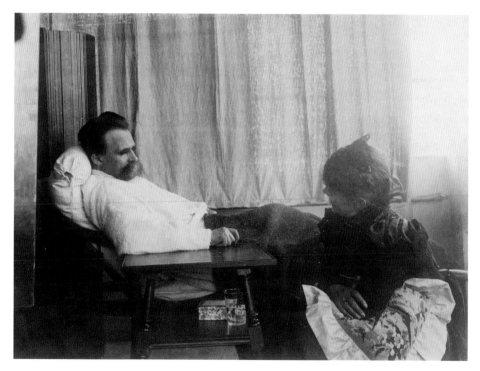

Friedrich Nietzsche and Elisabeth Förster-Nietzsche, photo: Hans Olde, 1899

**FRIEDRICH NIETZSCHE, THE PHILOSOPHER** and indisputably the most important thinker of the outgoing nineteenth century, became a messianic figure for a young generation of artists and intellectuals. His readers venerated him as a trailblazing innovator, seeing him as the prophet of a new vision of humanity. 'The Faust of the nineteenth century', 'dynamite' or 'monster' were just some of the attributes conferred on him by admirers and opponents alike. Unparalleled in this period were the radicalism and contrariness of his writings and the stylisation of his persona, the latter having been instigated by means of photographic portraits in the pose of the thinker, commissioned by Nietzsche himself, from 1882 onwards .

The cult around Nietzsche simultaneously took hold: the Nietzsche-Archiv, established by his sister, Elisabeth Förster-Nietzsche, in Weimar in 1896 became a place of pilgrimage and a centre of cultish devotion, to which reports of numerous ceremonies bear witness. The sick and benighted philosopher, whose sister had had him fetched from Naumburg to Weimar, was presented to selected visitors, reclining on a sofa and wearing a white coat. Awestruck followers recounting these encounters described him as a 'shackled Prometheus' and 'prophet of divine simplicity'. The letters and writings of Nietzsche, published on Förster-Nietzsche's instructions and sometimes containing distortions of his work, enlarged his fame; his striking portrait was disseminated in numerous sculptures. Nor did the attributes ascribed to Nietzsche diminish in the twentieth century: from 'war philosopher' during the First World War to 'prophet of the Third Reich' and 'Hitler's intellectual pioneer', the epithets projected onto him were myriad. The cult around Nietzsche has endured to this day, particularly on the Internet.

The political appropriation of the philosopher commenced in the mid 1920s: Förster-Nietzsche, head of the archive and a lifelong

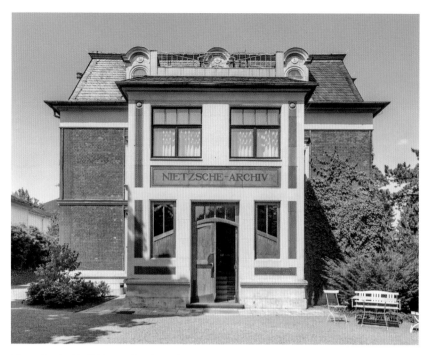

Nietzsche-Archiv, Weimar, view from the east, 2018

German nationalist sympathiser, began by professing open support for Italian fascism. Benito Mussolini, the founder and leader (*Il Duce*) of Italy's fascist movement from 1919 and prime minister of the Kingdom of Italy from 1922 to 1943, was a fervent devotee of Nietzsche. He also supported the archive financially and bequeathed it an ancient statue. After the First World War, Mussolini, inspired by Nietzsche's writings, proclaimed that fascism was the majestic creation of one human being and of a national 'will to power'. Not long afterwards in Weimar, the National Socialist regime instrumentalised Nietzsche's persona , celebrating him in 1930 in the party organ the *Völkische Beobachter* as the 'forerunner of the National Socialist movement'. Wilhelm Frick, a staunch National Socialist and, from 1930, Thuringia's Minister of Education and Internal Affairs, soon made contact with the archive and Förster-Nietzsche to further the implementation of his cultural policy. The archive's director, but particularly also her staff, celebrated the Nazis' seizure of power in 1933

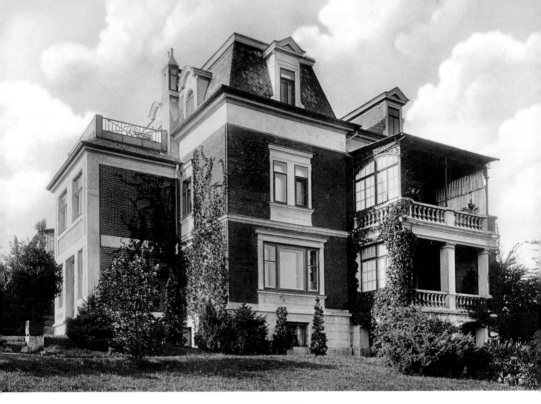

Nietzsche-Archiv, Weimar, view from the north-east, c.1905

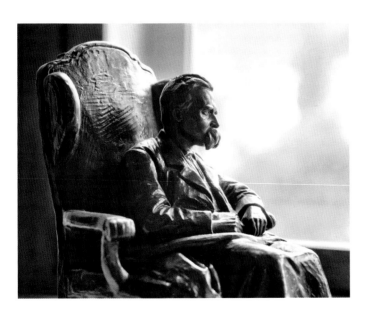

Arnold Kramer, *Friedrich Nietzsche in an Invalid Chair*, 1898. Ever since its completion, the statuette has been exhibited at the Nietzsche-Archiv in Weimar.

Statue of Dionysus. Benito Mussolini donated the ancient statue in 1943 for the apse of the Nietzsche Memorial Hall. After arriving in Weimar, it was never installed in that building, which remained unfinished throughout the Nazi period. In 1954 the Nationalen Forschungs- und Gedenkstätten der Klassischen Deutschen Literatur of East Germany transferred it to the Pergamon Museum in Berlin on permanent loan, and in the 1990s it was restituted to the Museo Nazionale delle Terme in Rome.

with euphoria. Other prominent Nazis visited the archive: in 1934 Adolf Rosenberg, the 'chief ideologist of the NSDAP (National Socialist Party)', and later Adolf Hitler himself. Hitler also initiated the construction of a prestigious Nietzsche Memorial Hall and financed this with a grant of 50,000 reichsmarks from his own funds. Back in 1911, Count Harry Kessler and Henry van de Velde had already planned a monumental memorial site for Nietzsche in Weimar, complete with a stadium and a temple, but funding difficulties had prevented the project from being realised. Now, under very different political auspices, the architect Paul Schultze-Naumburg, who had been director of the Weimar art schools since 1930, was an active member of the NSDAP

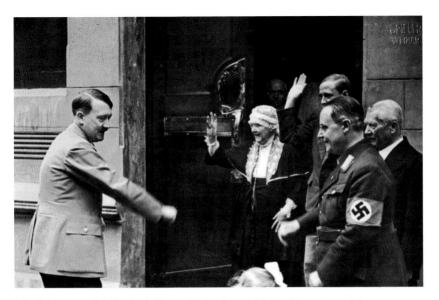

Adolf Hitler greeting Elisabeth Förster-Nietzsche outside the Nietzsche-Archiv on 20 July 1934

and politically and aesthetically radicalised, was commissioned in 1935 to erect a cult and archive building on a plot of land beside the archive. The Second World War prolonged completion of the building work until 1944.

In the Soviet Occupation Zone and in the German Democratic Republic (GDR), Nietzsche was *persona non grata,* and the Nietzsche-Archiv was effectively broken up. Nietzsche's writings and his library were transferred to the corresponding institutions of the Nationalen Forschungs- und Gedenkstätten der Klassischen Deutschen Literatur (NFG; National Research and Memorial Sites of Classical German Literature in Weimar), where they were placed in the safekeeping of conservators but could still be used for academic purposes. The furnishings of the archive were handed over to the Goethe National Museum. The archive building was used by the NFG as a guesthouse, and the cult hall beside the archive became the broadcasting studio of the local radio station.

Friedrich Nietzsche himself approached his readers in various guises. The best known is that of Zarathustra from one of his major works, *Also sprach Zarathustra* (*Thus Spoke Zarathustra*)

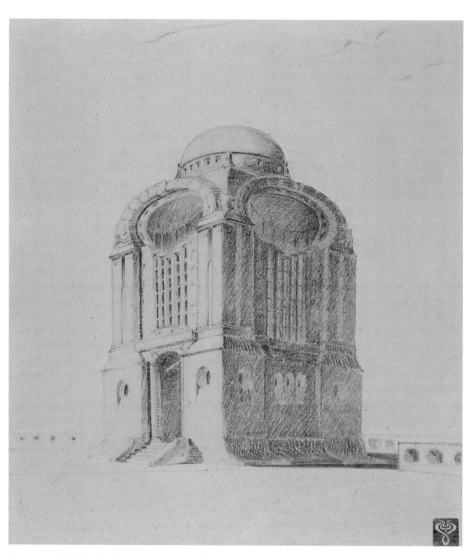

Henry van de Velde, Design drawing for the Nietzsche monument in Weimar, 1912

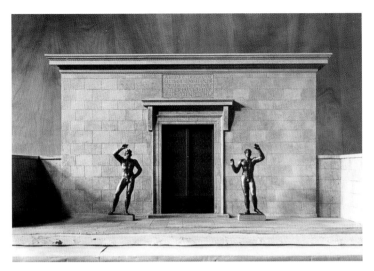

Paul Schultze-Naumburg, Model of the Nietzsche Memorial Hall for Weimar, portal and models of the statues of Dionysus and Apollo by Emil Hipp, 1937

(1882–85). Nietzsche was referring to the ancient Iranian prophet and spiritual leader Zoroaster. He envisaged the book as an epic narrative of humanity, rife with religious symbolism, and spoke of it as the 'Bible of the future'. Its contents included discussion of the *Übermensch* (superior human) and thoughts on the 'eternal recurrence of the same' and the 'will to power'. Many devotees read the book like a revelation; it inspired musicians such as Richard Strauss to great symphonic poems.

In 1897, Förster-Nietzsche commissioned Kessler with a special edition. For the book design he secured the services of Henry van de Velde. The *Zarathustra* designed by the Belgian art reformer is considered one of the most exquisite Jugendstil book covers ever made. The cult book attained wide circulation in 1916 thanks to a plain wartime edition printed in a huge edition, which prompted the artist George Grosz to remark sarcastically: 'Goethe in the shellfire, Jesus in the trench, Nietzsche in the knapsack'.

## Curt Stoeving

## Death mask of Friedrich Nietzsche, 1900

After Friedrich Nietzsche's death, on 25 August 1900, his sister, Elisabeth Förster-Nietzsche, did her utmost to organise his posthumous fame. A hurried telegraph was sent to Max Klinger, one of Germany's most celebrated artists at the time, urging him to cast the death mask. As Klinger was unable to attend to the request, Curt Stoeving, who had painted Nietzsche's portrait some time previously, cast an impression of his visage with Count Harry Kessler, although he had no experience in doing so. His mask turned out only moderately well: the right eyebrow is askew, and the beard lacks any contours. The mask became a relic; a corrected version was reproduced by bronze casting and later disseminated by the Nietzsche-Archiv to the philosopher's devotees as a plaster cast. Klinger was implored to produce a revised, authorised version, but in vain. He did, however, make use of the models he was sent for his first Nietzsche bust, of 1902. To this day, casts of Nietzsche death masks from various sources are offered – the cult around Friedrich Nietzsche shows no sign of abating. UB

# NO CONCESSIONS FOR THE PETIT BOURGEOIS

## The New Weimar and its protagonists

THOMAS FÖHL

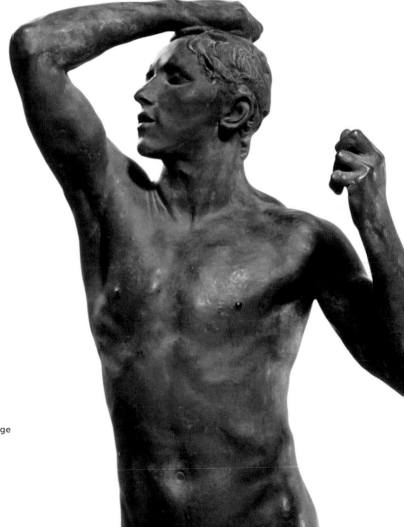

Auguste Rodin,
*L'Age d'Airain* (The Age
of Bronze), 1875–76

'IF EVER POVERTY was covered up by wealth, it happened here.' In this one sentence, Hermann Broch perfectly summed up the oppressive decades of historicism in the first chapter of his 1955 study *Hofmannsthal und seine Zeit* (*Hugo von Hofmannsthal and His Time*).

Count Harry Kessler and Henry van de Velde would have readily subscribed to Broch's verdict. Elisabeth Förster-Nietzsche may have as well – up to a point. Most agree that the sister of the famous philosopher who had passed away in 1900 was indeed the one who heralded a new beginning in Weimar. It was she who outlined a reform programme in a letter to Kessler on 22 March 1901, which van de Velde strived to implement in the Grand Duchy of Saxony-Weimar-Eisenach in the following years. Moreover, she was ready to advocate – and tirelessly so – for van de Velde's appointment as advisor to the grand duke, which she, Kessler and mutual friends finally achieved at the end of 1901. From 1902 to 1917 the famous Flemish artist spent his most successful and productive period of his long life in Weimar. In his first commission, he supervised the refurbishment of the Nietzsche-Archiv, which served to demonstrate his 'New Style' and make the archive a memorial site befitting the standing of the great Nietzsche. The time was well chosen. In hindsight, van de Velde wryly admitted in his 1962 memoire, *Geschichte meines Lebens* (History of my life): 'A new vein of gold – the cult of Friedrich Nietzsche – was discovered at the moment when the mediocrity of the Goethe priests threatened to debase the Goethe cult.'

As the third party of this company, Kessler rented an apartment in Weimar in 1902 and assumed his post as director of the Grossherzogliche Museum für Kunst und Kunstgewerbe (Grand Ducal Museum of Arts and Crafts) in March 1903. With the backing of the Nietzsche-Archiv and his close ties to van de Velde and Europe's cultural elite, Count Kessler travelled constantly between London,

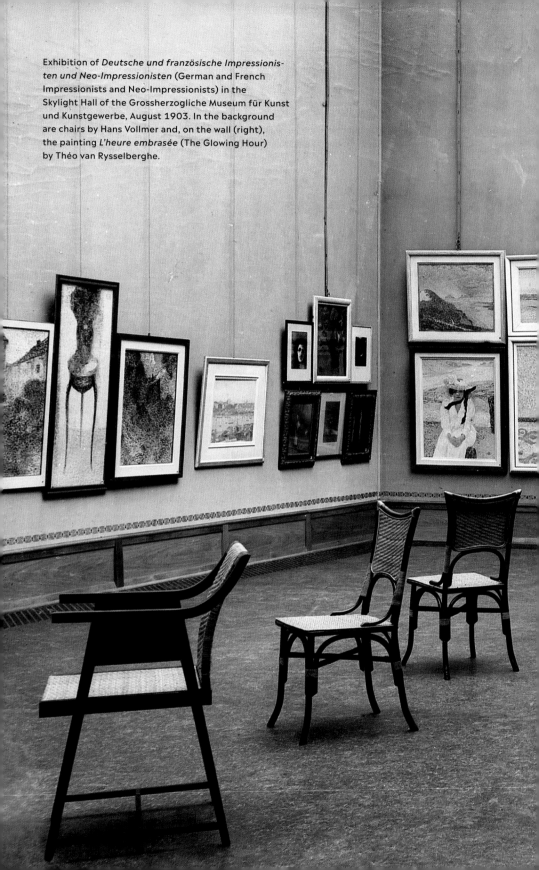

Exhibition of *Deutsche und französische Impressionisten und Neo-Impressionisten* (German and French Impressionists and Neo-Impressionists) in the Skylight Hall of the Grossherzogliche Museum für Kunst und Kunstgewerbe, August 1903. In the background are chairs by Hans Vollmer and, on the wall (right), the painting *L'heure embrasée* (The Glowing Hour) by Théo van Rysselberghe.

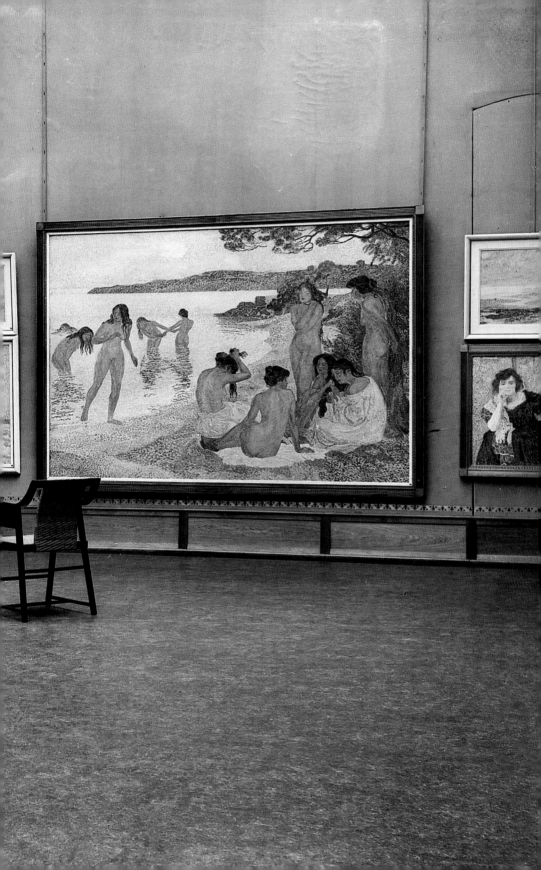

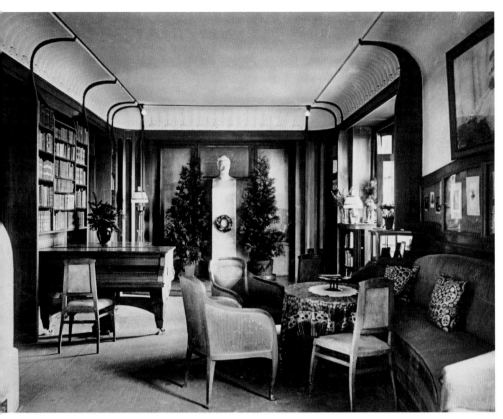

Henry van de Velde, Library room in the Nietzsche-Archiv, Weimar, after 1905

Weimar, Paris and Berlin in hopes of establishing Weimar as a new powerhouse of modern intellectual culture. His aim was to elevate the culturally loaded image of the 'Athens on the Ilm' associated with Classical Weimar to new heights, and this explicitly against the will of the emperor, who not only expressed disdain for van de Velde but also scorned modernism in general as 'gutter art'. While Kessler's vision ultimately proved far too ambitious for Weimar, in the beginning, everything proceeded according to plan.

Prior to his resignation, in July 1906, Kessler organised some 30 ground-breaking exhibitions which shifted modernism to the fore in the German empire. With the help of an art patron, he also began purchasing outstanding paintings and sculptures, which account for some of the most valuable works in the Weimar collections today.

In December 1903 he founded the Deutsche Künstlerbund (Association of German Artists) at his museum. In this he was able to secure the patronage of the Grand Duke Wilhelm Ernst himself. The duke's young wife, Caroline, also helped finance the first acquisitions. The plan seemed to be working. All of Europe looked to Weimar with growing interest. One felt honoured to hold readings and lectures in the Nietzsche-Archiv and the Schloss Belvedere (Belvedere Palace) park. Well-known literary figures like Gerhart Hauptmann, Richard Dehmel, Hugo von Hofmannsthal and André Gide were invited to Weimar along with such famous artists as Max Klinger, Edward Gordon Craig, Edvard Munch and Théo van Rysselberghe.

Initially the Nietzsche-Archiv represented the centre of this circle, but it also welcomed top scholars of Nietzsche philology and reception and a large number of prominent visitors who had met and corresponded regularly with Nietzsche's very active sister before the philosopher's death. Weimar experienced a cultural renaissance.

Ludwig von Hofmann, *Grape Harvest*, 1906

After establishing the Künstlerbund, Kessler immediately turned his attention to other projects, developed an innovative art book edition of German classics for Insel Verlag, planned to start a printing company of his own and completely refurbished his museum. In 1906 he initiated the first exhibition of modern German artists in the British capital and organised an exhibition of the Künstlerbund in Weimar that same year. Kessler also drafted an open letter which was signed by the most influential scholars of both countries and published in every prominent English and German journal and newspaper in January 1906 in an attempt to assuage the tense political relations between the two nations. The New Weimar was off to a magnificent start.

Van de Velde designed a 'model apartment' to host receptions of up to 20 guests, on the two floors that Kessler had initially rented at Cranachstrasse 3. In addition to the furniture, every detail was devised to harmonise together as a *Gesamtkunstwerk*, a total work of art. Kessler, who became an ardent supporter of modernism ever since meeting van de Velde in 1897, also purchased a series of paintings and established his salon that – together with the Nietzsche-Archiv – expressed their jointly held vision to Weimar's court society.

Grand Duke Wilhelm Ernst (1876–1923) appeared to be open to these ideas, at least initially; starting in 1904, he supported the construction of a new art school and later agreed to finance van de Velde's school of arts and crafts.

Despite considerable efforts, van de Velde failed to land any further public commissions. Disappointed, he concentrated instead on working for private clients and building his school. When Kessler resigned his post in 1906, due to a petty dispute, the Belgian designer responded defiantly, as if to say, 'Now we'll really show them!'; he started designing his second private home, the Haus Hohe Pappeln, outside of Ehringsdorf, which was completed and ready for occupancy in 1908.

Count Harry Kessler's dining room at Cranachstrasse 3, since 1906 no. 15, Weimar, photo: Louis Held, 1909. Of the furniture designed by Henry van de Velde, only the chairs have survived (Klassik Stiftung Weimar); the frieze by Maurice Denis has been lost. Auguste Renoir's painting *Marchande de pommes* is now held in the Cleveland Museum of Art.

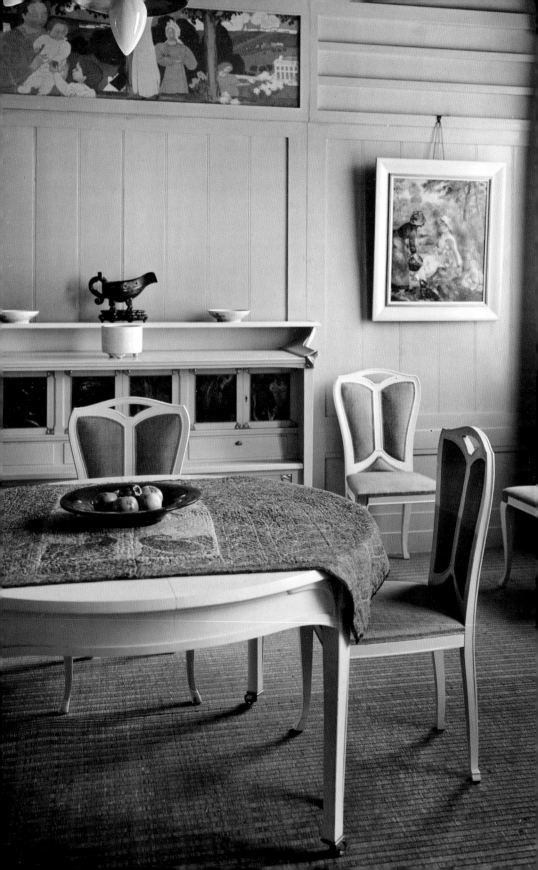

Georg Kolbe, *Henry van de Velde*, 1913

One could argue that by 1906 at the latest, the New Weimar experiment had failed. Its protagonists refused to be discouraged, however, and continued pursuing their goals at the private level. In the final paragraph of a letter to Nietzsche's sister on 6 October 1906, Kessler wrote: 'I look forward with unclouded joy to the development of our circle in Weimar in the years ahead, when we must no longer defer to the concerns of the petit bourgeois at court. Many of us will be away this year; but starting next autumn we shall rally around you and the archive like a fortress and only permit the truly legitimate comrades-in-arms to approach.'

Van de Velde's work room in the apartment at Lassenstrasse 29, Weimar, 1906

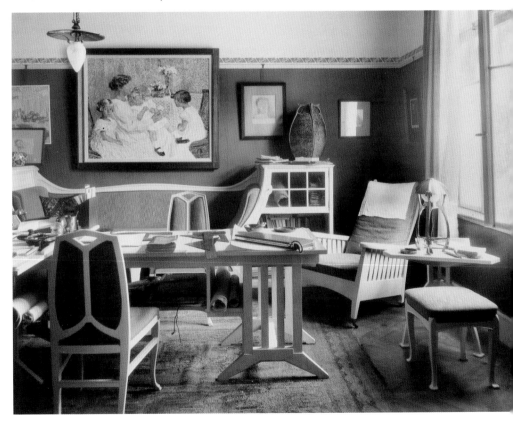

# Henry van de Velde/Otto Dorfner

## Binding for Nietzsche's
## *Thus Spoke Zarathustra*, 1914

Insel Verlag, Leipzig, 1908, private collection. The decoration of the special edition was designed by Henry van de Velde in 1914 and executed by Otto Dorfner in Weimar.

One of the Friedrich Nietzsche's best-known works, *Also sprach Zarathustra* (*Thus Spoke Zarathustra*), was the first project of the 'New Weimar'. With the approval of Elisabeth Förster-Nietzsche, Count Harry Kessler spontaneously commissioned the relatively unknown Henry van de Velde to design the book's typography in 1897. It wasn't until 1908 that the edition featuring van de Velde's overall design was finally published by Insel Verlag. The opulent edition depicted here was created by Otto Dorfner for the first-ever *International Exhibition of the Book Industry and Graphic Arts*, in Leipzig in 1914.
Although the original design was Henry van de Velde's, the ornamental lettering in the title was created by Dorfner himself. This luxurious edition of *Zarathustra* was a sensational success for the publishing house. The owner, Anton Kippenberg, had Dorfner make bindings for at least five more copies, including two with a blue cover, which he sold for a staggering price. TF

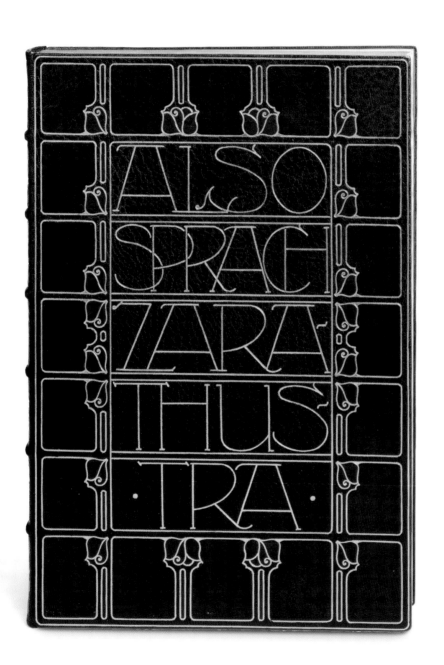

# CONTROVERSIES SURROUNDING THE EUROPEAN AVANT-GARDE

## Count Harry Kessler as museum director

GERDA WENDERMANN

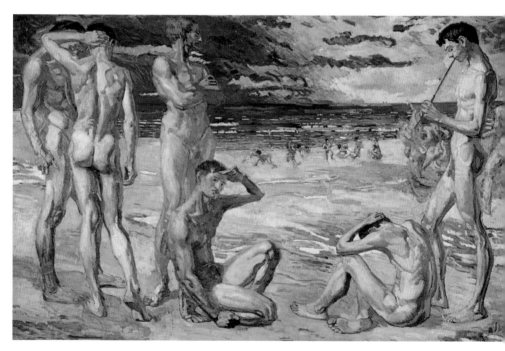

Max Beckmann, *Young Men by the Sea*, 1905

IN THE SPRING OF 1889, the Hamburg art critic and collector Emil Heilbut held several lectures at the Grossherzogliche Kunstschule Weimar (Grand Ducal Art School) in Weimar on contemporary French painting, during which he presented three landscape paintings by Claude Monet from his personal collection. At the beginning of the 1890s, further Impressionist paintings by Monet, Alfred Sisley, Camille Pissarro and Edgar Degas were shown in the *Permanente Ausstellung für Kunst und Kunstgewerbe* (Permanent Exhibition of the Arts and Crafts) in cooperation with the Parisian art gallery Goupil & Cie. Several Weimar painters, including Christian Rohlfs and Ludwig von Gleichen-Russwurm, were immediately inspired by these new impressions. From then on, they began working with bright, thickly applied paints and using more relaxed brushstrokes to convey the light and chromatic mood at certain times of day. Theodor Hagen embraced the new style as well.

Count Harry Kessler became a part of this burgeoning movement when he decided, in April 1902, to work as the honorary chairperson in a committee appointed to convert the permanent exhibition into a modern museum for art and the arts and crafts. Its board members included Henry van de Velde and Hans Olde. The indefatigable, sophisticated art connoisseur Kessler saw himself as a kind of general director who, in collaboration with artists, artisans and educators, aimed at initiating a fundamental reform. In March 1903 he officially assumed his office. In the following years, between his frequent trips back and forth between Berlin, Paris and London, Kessler succeeded in attracting writers and internationally renowned artists, such as Rainer Maria Rilke and Maurice Denis, to the city on the Ilm. He pursued his project of a New Weimar at great personal and financial expense in hopes of ushering in Germany's cultural renewal. Van de Velde played a central role

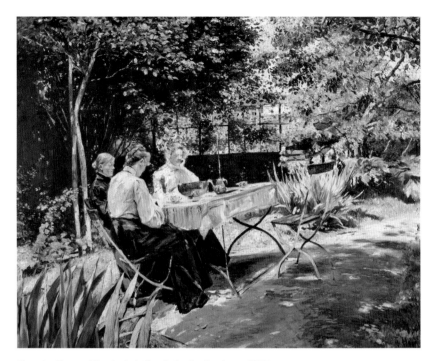

Theodor Hagen, *The Artist's Family in the Garden*, c.1905

in this project as Kessler hoped he would invoke a 'renaissance of modern art'.

With over 30 exhibitions of contemporary works by German, French and English avant-gardists, which Kessler cleverly inter-mingled with presentations by local artists, he officially welcomed the advent of modernism to Classical Weimar. Like nowhere else in Germany, the public was presented with a rapid succession of exhibitions between 1903 and 1906 featuring works by the French Impressionists, Neo-Impressionists and the group Les Nabis asso-ciated with Paul Gauguin. With a focus on Neo-Impressionist art-ists, Kessler's exhibition policies may have reflected his and van de Velde's aesthetic preferences; they also evoked an international re-assessment of this style, which had lost some of its relevance follow-ing the death of its founder, Georges Seurat, in 1892, although it was revitalised by Paul Signac and Henri Edmond Cross at the end of the 1890s. In addition to his privately owned works, Kessler acquired

Ludwig von Gleichen-Russwurm, *On the Cliffs of Helgoland*, c.1890

and presented numerous loans from friends and fellow collectors, including Kurt von Mutzenbecher, Eberhard von Bodenhausen, Karl Ernst Osthaus, Alfred and Helene von Nostitz, as well as the well-known Parisian art dealers Bernheim-Jeune, Paul Durand-Ruel and Ambroise Vollard.

The exhibition *Deutsche und französische Impressionisten und Neo-Impressionisten* (German and French Impressionists and Neo-Impressionists) opened on 1 August 1903. It was based on a selection of works from the Galerie Cassirer, organised by the Berlin painter Curt Herrmann, one of the earliest German representatives of Neo-Impressionism, and supplemented by several loans acquired by Kessler. The richly diverse selection included pieces by Pierre Bonnard, Cross, Denis, Théo van Rysselberghe, Signac, Maximilien Luce, Édouard Vuillard and Odilon Redon, as well as paintings by two German artists, namely Curt Herrmann himself and Paul Baum. The show was quickly followed by two further Neo-Impressionist

Paul Baum, *View of Constantinople*, 1901, permanent loan from
the Curt Herrmann Heritage Foundation

Henry van de Velde, *Winter Sun*, 1892

Max Liebermann, *The Artist's Wife at the Beach*, c.1898

exhibitions, in November 1904 and February 1905, which further increased public awareness of this artistic movement in Germany.

Thanks to a generous endowment financed by the art patron and founder of the Insel Verlag, Alfred Walter Heymel, with whom both Kessler and van de Velde were personal friends, the new museum director had the considerable fortune of 50,000 marks at his disposal for new acquisitions. Kessler began by purchasing the large-scale painting *Bathing Women* by the Belgian artist van Rysselberghe, which he had shown in the first Neo-Impressionist exhibition, for 8,000 marks, and an even more expensive *Rouen Cathedral* by Monet for 16,000 marks, which was shown at the second Monet exhibition in Weimar, in 1905. It was one of the first works of French Impressionism purchased for display in a German museum.

As one of the decisive co-founding members of the Deutsche Künstlerbund, Kessler also ensured that the third Künstlerbund exhibition would take place at the Grossherzogliche Museum (Grand

Théo van Rysselberghe, *L'heure embrasée* (The Glowing Hour), 1897

Ducal Museum) in the summer of 1906. He expressed particular interest in the painting *Young Men at the Sea* by the young Max Beckmann. Not only did Kessler push to have the Villa Romana Prize awarded to this yet unknown artist who had studied at the Grand Ducal Saxon Art School under the Norwegian painter Carl Frithjof Smith; he also emphatically supported the purchase of the painting with funds from the Heymel endowment. Thus began Beckmann's artistic career in Weimar.

By this time, Kessler's position in Weimar had become the subject of controversy. Conservative opposition was building with calls to topple him. In 1904 Kessler had been in the good graces of the artistically minded Grand Duchess Caroline, who had facilitated the spectacular purchase of Auguste Rodin's masterpiece *The Bronze Age*

from Rodin's first solo exhibition in Weimar. But all that changed when a major scandal erupted following the opening of the second Rodin exhibition, in January 1906. The public protested at the alleged obscenity of Rodin's erotic nude portraits, which the French artist had dedicated to the grand duke. Wilhelm Ernst demonstratively withheld his support from Kessler, whereupon Kessler submitted his resignation one month later.

Auguste Rodin, *Etude du nu* (Nude Study), c.1900

## Claude Monet

### *Le Cathédrale de Rouen* (Rouen Cathedral), 1894

This painting belongs to Claude Monet's most famous series, comprising a total of 30 views of Rouen Cathedral painted between 1892 and 1894. They depict a section of the façade of the monumental late Gothic church with its three main portals and large central rose window. Monet was fascinated by the appearance of the façade, with its constant interplays of light from early morning to sunset, which he tried to capture anew on canvas every hour. The Weimar painting was made in the early morning hours when the portals were still ensconced in shadow while the north tower was already radiant with the golden light of morning. By applying impasto paint with short, crisscrossed brushstrokes, Monet was able to create a vibrant surface. GW

# A NEW START
# IN EDUCATION
## The reform
## of the art school

GERDA WENDERMANN

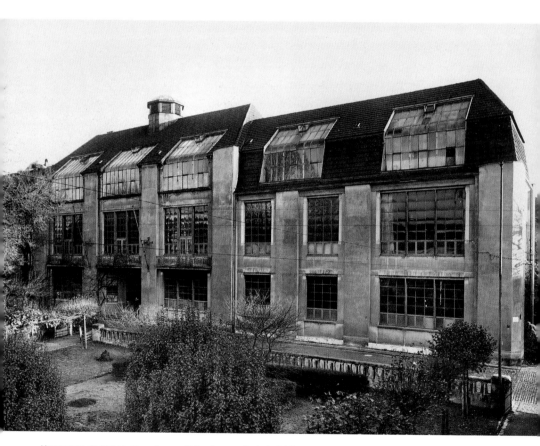

Henry van de Velde, Grossherzogliche Kunstschule in Weimar, 1904–11,
photo: Louis Held, c.1926

**THE DEATH OF GRAND DUKE** Carl Alexander, in January 1901, and the succession of his grandson Wilhelm Ernst had far-reaching consequences for the Weimar Art School, which was reorganised and converted into a public institution, the Grossherzoglich Sächsische Kunstschule Weimar (Grand Ducal Saxon Art School), in 1902. A significant change in direction was set in motion by the appointment of the northern German artist Hans Olde, on 1 April 1902, as the school's new director. One of the earliest exponents of Impressionism in Germany, Olde belonged to that illustrious circle of artists at the Berlin art journal *Pan*, to which Count Harry Kessler also contributed. As soon as he took office, Olde went straight to work implementing a fundamental reform of the school. In anticipation of the Bauhaus mission proposed by Walter Gropius, the academy would now expressly focus on educating students in the trades and handicrafts as the basis for artistic activity in all areas of the fine and applied arts. As a result, the art academy gradually expanded to include a graphic arts department, a printing shop for training purposes and, in 1907, a technical colour laboratory, which produced a newly developed synthetic paint called the *Weimar-Farbe* (Weimar paint). A sculpting department was also established and headed by Olde's Berlin friend Adolf Brütt from 1905 to 1910.

One of the reform measures that Olde implemented starting in the winter term of 1902 was the first-time admission of female students, who until then could only enrol in private art schools in Germany. Among the first 18 women who were officially entitled to receive the same artistic education as their fellow male students was Minna Tube, who met Max Beckmann there. The two married after Beckmann completed his art programme, in 1906. Women and men received instruction in separate classes, and only the art history lectures by Otto Eggeling could be jointly attended. Margarete Geibel

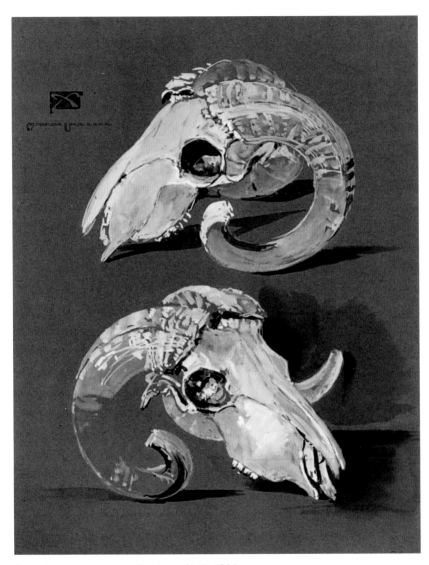

Magda Langenstrass-Uhlig, *Two Rams' Skulls*, 1906

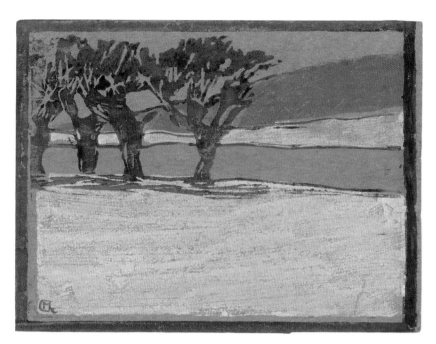

Margarete Geibel, *Willows*, 1904

began her education at the Fürstliche freie Zeichenschule Weimar (Weimar Princely Free Drawing School), an institution initiated by Johann Wolfgang von Goethe, and later took private lessons from Otto Rasch. Magda Langenstrass-Uhlig also attended the school and first enrolled at the Kunstschule Weimar in 1907. She received her diploma in painting in 1911 and – after her marriage and the birth of her two daughters – completed a second course of study at the Bauhaus in Weimar and Dessau, from 1924 to 1926.

Olde brought new blood to the teaching staff with the appointment of two young instructors, Ludwig von Hofmann and Sascha Schneider. Hofmann, who arrived in Weimar in 1903, was one of Germany's most influential colourists. During a one-year study visit in Paris in 1889, he became acquainted with the mural paintings of Pierre Puvis de Chavannes and Albert Besnard and was influenced by their synthesis of decorative design and colouring with regard to their content and style. Moreover, his encounter with works by the French Impressionists and Neo-Impressionists, as well as the Nabis

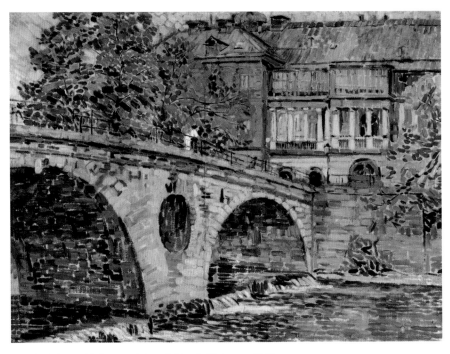

Ludwig von Hofmann, *Palace Bridge in Weimar*, c.1910

artists associated with Pierre Bonnard and Maurice Denis, helped him gain a new appreciation of colour and form. In contrast to the naturalist-realist tendencies of his time, Hofmann worked to create an idealistic counter-reality by using bright, 'non-natural' colours and presenting his figures in classical poses. Indeed, this artistic intention made him an important role model for his students. These included Moriz Melzer, Otto Illies, Ivo Hauptmann, the eldest son of the famous playwright Gerhart Hauptmann, and Hans Arp, who would later become a renowned Dadaist. Together with Olde's students they showed their work publicly for the first time in a 1907 exhibition at the Grossherzogliche Museum für Kunst und Kunstgewerbe (Grand Ducal Museum of Arts and Crafts), where they presented paintings, pastels and drawings in an advanced Neo-Impressionistic style.

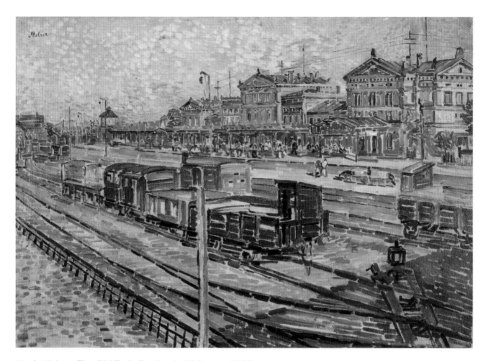

Moriz Melzer, *The Old Train Station in Weimar, c.*1905

Contemporary critics reacted very positively to the reform of the art academy and its effects. As Hans Rosenhagen commented in 1903: 'It [the school] should not produce specialists, not portrait painters, historical painters, genre and landscape painters, but artists in general who possess good technical skills and can become anything, also decorative painters and artisans.'

## Hans Olde

## *The Reaper*, 1893

Hans Olde's second trip to Paris, in 1891, five years after studying with Lovis Corinth at the prestigious Académie Julian, turned out to be a life-altering experience. There, for the first time, he encountered works by Claude Monet, which inspired his turn to Impressionism. His early masterpiece *The Reaper* is furthermore characterised by a modified application of the Neo-Impressionistic separation of colour. On a visit to the tenth annual exhibition of the Belgian artists' group Les Vingt, in Brussels in the spring of 1893, he had an opportunity to study paintings by leading representatives of Neo-Impressionism, such as Paul Signac, Henri Edmond Cross and Théo van Rysselberghe, for the first time. GW

# THE GRAND DUCAL SAXON SCHOOL OF ARTS AND CRAFTS IN WEIMAR

## Henry van de Velde's first citadel of modernism

SABINE WALTER

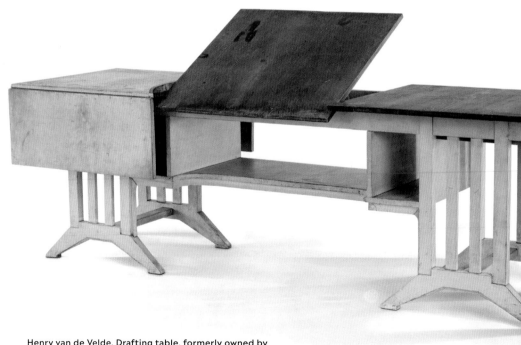

Henry van de Velde, Drafting table, formerly owned by
Henry van de Velde, 1902, permanent loan from a private collection

FOR COUNT HARRY KESSLER and Elisabeth Förster-Nietzsche, the famous Henry van de Velde was the determining guarantor for their daring plans to recast the classical city into a 'New Weimar'. As artistic advisor, van de Velde was to provide aesthetic expertise and support to the handicrafts and industry in the grand duchy. The grand duke hoped that increasing production in the spirit of modernism would result in an expanding economy, and thus granted the Belgian designer a professorship in 1902. Van de Velde was given rooms in two auxiliary art school buildings to work in and develop new products for interested companies. Dissatisfied with the limited success of his mission, van de Velde established his own training facility in 1904. This first 'citadel of modernism', as he called it, which he designed across from his newly established art school, was part of a new academic complex. He designed the building as a *Gesamtkunstwerk*, with harmoniously matched furnishings. In addition to the arts and crafts workshops, the facility included the art school's sculpting studio and his own private studio. Although both male and female students began enrolling in 1906, the Grossherzoglich Sächsische Kunstgewerbeschule Weimar (Grand Ducal Saxon School of Arts and Crafts) only officially opened in 1908, with the aim of promoting the handicrafts and art industry through theoretical and practical training courses.

Rejecting traditional trade school models, van de Velde also introduced elementary courses and workshop instruction. As at numerous other academic institutes devoted to the art school movement, students began by developing a sense of ornamentation and colour by means of abstract exercises. The basic study phase of their programme included a perspective drawing course and an introduction to the arts and crafts. This was followed by specialisation in the workshops. In contrast to the typical master classes offered at the academies or the heavy theoretical focus of the trade schools, van

Katharina Determann, born Ulrich, *Corridor on the Upper Floor of the Grand Ducal School of Arts and Crafts in Weimar*, 1912–13

Henry van de Velde, Grossherzogliche Kunstgewerbeschule in Weimar, 1905–06, photo: Louis Held, 1907

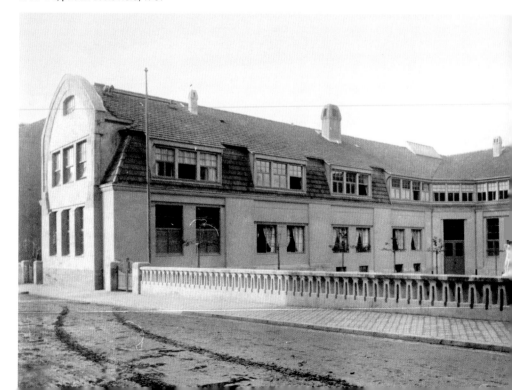

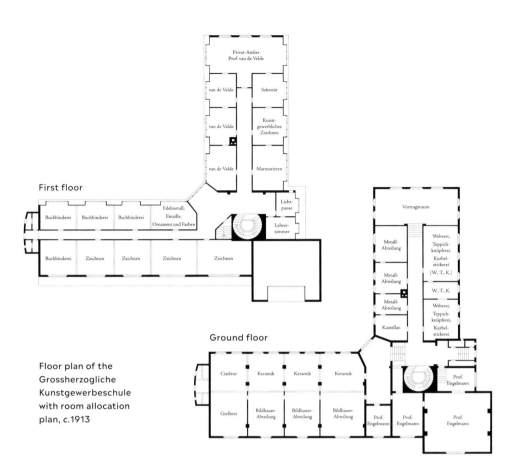

**First floor**

| | | | |
|---|---|---|---|
| | | Privat-Atelier Prof. van de Velde | |
| | van de Velde | Sekretär | |
| | van de Velde | Kunstgewerbliches Zeichnen | |
| | van de Velde | Marmorieren | |

Lichtpause

Lehrerzimmer

| Buchbinderei | Buchbinderei | Buchbinderei | Edelmetall, Emaille, Ornament und Farben |
|---|---|---|---|
| Buchbinderei | Zeichnen | Zeichnen | Zeichnen | Zeichnen |

**Ground floor**

Vortragsraum

| Metall-Abteilung | Weberei, Teppich-knüpferei, Kurbel-stickerei (W., T., K.) |
|---|---|
| Metall-Abteilung | W., T., K. |
| Metall-Abteilung | Weberei, Teppich-knüpferei, Kurbel-stickerei |
| Kastellan | |

Prof. Engelmann

| Ciseleur | Keramik | Keramik | Keramik |
|---|---|---|---|
| Gießerei | Bildhauer-Abteilung | Bildhauer-Abteilung | Bildhauer-Abteilung | Prof. Engelmann | Prof. Engelmann | Prof. Engelmann |

Floor plan of the Grossherzogliche Kunstgewerbeschule with room allocation plan, c.1913

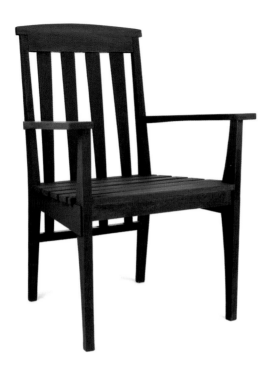

Henry van de Velde, Armchair from the Weimar school of arts and crafts, c.1906, purchased for the museum by the Weimarer Kunstgesellschaft e.V. with support from Fielmann AG

de Velde advocated the 'workshop principle' in Weimar. In what he called 'laboratories', the students experimented with various materials and their characteristics. Workshops were offered in ceramics and porcelain painting, engraving, enamel and metalworking, and precious metalworking. There was also a rug-making workshop, a weaving workshop with crank embroidery machinery, and the most productive department – the bookbinding workshop. The diverse curriculum included courses in handmade paper and batik fabrics, as well as typeface design and calligraphy. The goal of the programme was to provide artistic education. In collaboration with the instructors, students were expected to develop their own views on design in the sense of modernist aesthetics.

Some of the instructors were employed in van de Velde's private studio; other local artisans were recruited for the school, where they set up their private workshops. As at many arts and crafts schools, a large percentage of the instructors were women. Women were predominantly represented in the area of textile arts. Yet, two students,

Dorothea Seeligmüller and Dora Wibiral, also succeeded in studying ornamental drawing, precious metalworking and enamel art. Out of the 383 enrolled students, 230 were young women from an upper-class or aristocratic background. For these women, the school with its high professional standards offered an attractive supplement and alternative to the usual finishing schools for upper-class daughters who were preparing for marriage. As for the male students, many had already completed vocational training; they either came from families of craftsmen or were sent by their companies to gain additional artistic qualification.

While the state expected that students receive a solid education in the trades and handicrafts, van de Velde taught his students to become self-confident artists. Inexperienced in administrative matters and caught up in the chaos of creating a new school, he often clashed with the authorities on the details. Due to insufficient funding from the grand duke's private coffers, the school of arts and crafts

Henry van de Velde in the studio of the school of arts and crafts, photo: Louis Held, 1906-07

Anne Lise Lohde, *Colour and Ornament Study for a Coloured Glazing*, 1911-12

and a number of instructors were forced to make ends meet by selling products manufactured in the workshops. Exasperated by the constant wrangling, van de Velde submitted his resignation in July 1914. The outgoing director recommended the designers and architects Hermann Obrist, August Endell and Walter Gropius as potential successors. When the school closed on 1 October 1915 to make space for a military hospital, the workshops moved out of the building. Only Helene Börner and Otto Dorfner were able to continue working in the weaving and bookbinding workshops on a private basis.

Van de Velde's lasting achievement was his success in offering modern education in all areas of the applied arts, later referred to as the decorative arts or design, in Weimar until 1915. In the areas of both teaching and practical application, he used the school of arts and crafts to implement his theories, which he had formulated in numerous essays and publications since the 1890s. The works produced by the instructors and students reflect his credo of designing 'reasonable' forms reduced to their basic functions. In aesthetically designed rooms, he advocated collective collaboration on equal footing, one of the key requirements and basic conditions of the creative process which van de Velde had long postulated. Between 1906

and 1915, the school of arts and crafts was driven by the idealism of everyone involved, yet it never managed to move beyond its original circumstances. It was van de Velde's successor, Walter Gropius, who finally succeeded in merging the art school and the school of arts and crafts in an institution that would combine the fine and applied arts in a joint curriculum. With the establishment of the Staatliche Bauhaus Weimar (Weimar State Bauhaus), in 1919, new artistic opportunities presented themselves in Weimar. Not only was the Bauhaus installed in the school buildings designed by van de Velde, it also incorporated the teaching staff and student bodies of both schools. Elementary courses and the workshop principle had long been established under van de Velde's direction. Even van de Velde's vision of creating simple and thus effective forms became a central aspect in the functional design concept promoted by the Bauhaus.

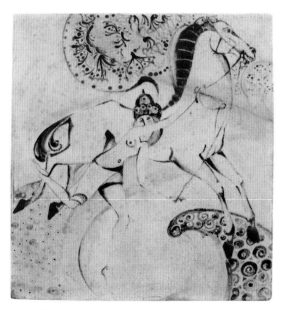

Agnes Peters, Tile, 1912

## Ellen Kolde

### *Fourfold Rotating Ornament*, 1910-11

Repulsed by the 'irritating legacy' of arbitrarily applied ornamentation, Henry van de Velde advocated what he considered to be a 'reasonable' design language at the school of arts and crafts. His mission was to ensure that ornaments were not used as superfluous add-ons. Rather, they should be an integral part of a balanced whole and inspire harmony and dynamism in the eye of the beholder. In this spirit, the student Ellen Kolde of Erlangen sketched a design featuring interweaving, pulsating lines whose rhythm exhibits the new force of modernism as van de Velde envisioned. The sheet was considered a success for it was one of the few works donated to the Grossherzogliche Museum in Weimar when the school of arts and crafts was dissolved, in 1915. sw

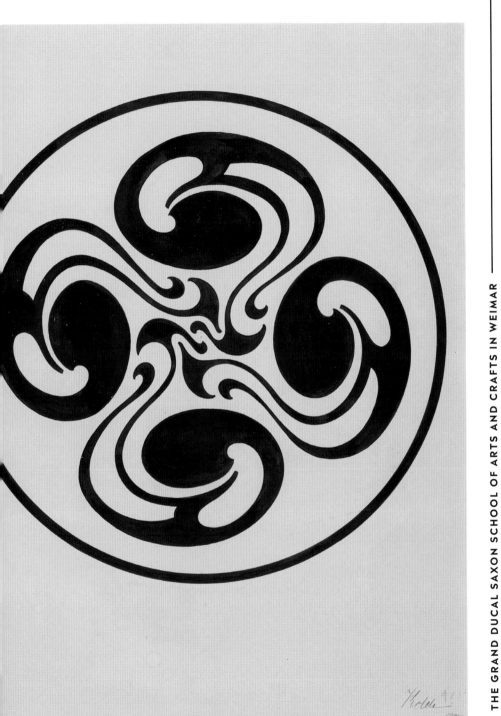

# THE NEW STYLE
## Henry van de Velde and the arts and crafts

ANTJE NEUMANN

Henry van de Velde, Vase, formerly owned by Johanna and Herbert Esche, Chemnitz, 1902, permanent loan from a private collection, Düsseldorf

Henry van de Velde, Brooch, formerly owned by Johanna and Herbert Esche, Chemnitz, 1904-05, acquired with support from the Kulturstiftung der Länder

LIKE MANY OF HIS CONTEMPORARIES, from 1890 Henry van de Velde was gripped and swept along by a wave of artistic reinvigoration. He engaged intensively with the English Arts and Crafts movement, Japanism and Symbolism, and pursued the idea of a renewal of art born of returning to artistic artisanship. With the aim of revitalising old production techniques and meeting the stylistic tumult of historicism with aesthetic clarity, he created the appliqué embroidery *Angels' Watch* in 1892–93, very consciously taking the step from painting to the arts and crafts.

Shortly thereafter, van de Velde designed his own residence, Bloemenwerf house, and its entire interior, down to reform dresses for his wife, Maria. The simple and unpretentious architecture of the house and its functional furniture were novel and sensational in their impact. Derived from the form of the Eiffel Tower in Paris, to this day the Bloemenwerf chair embodies functional elegance. Along with Gustave Serrurier-Bovy, Paul Hankar and Victor Horta, van de Velde was one of the leading designers in Belgium. He became the herald of a new style and an apostle with a mission, which he referred to as his 'apostolate' throughout his working life.

Facilitated by the *International Exhibition of Fine Arts*, in Dresden in the spring of 1897, van de Velde became known in Germany and increasingly received commissions from German clients. He moved the marketing of products from his workshops from Brussels to Berlin, and subsequently marked all his arts and crafts works with his artist's signet. He designed not only complete interiors for private houses, shops, banks, railway trains and ships, but also all manner of everyday utility objects. As an 'all-round artist' his mission was to

THE NEW STYLE

Henry van de Velde, *Angels' Watch*, 1892–93 (design 1892),
Museum für Gestaltung Zürich, Kunstgewerbesammlung

reunify the creative arts into a coherent artistic whole and foster a
renewed burgeoning of the arts and crafts.

Assisted by numerous patrons, in 1902 van de Velde was
appointed to a position in Weimar and founded the Kunstgewerbliche
Seminar (Arts and Crafts Seminar), from which the School of Arts and
Crafts ensued in 1908, and ultimately, in 1919, the Staatliche Bauhaus
Weimar (Weimar State Bauhaus). At the forefront of a new artistic
and cultural movement he thereby laid the foundation stone for mod-
ernism. He personally travelled through Thuringia to gather infor-
mation on-site about the state of each particular craft and to advise
the artisans artistically. He worked intensively with regional arts and
crafts industries and, through skilful involvement in exhibitions and
competitions, succeeded in publicly presenting the firms' modern-
ised product ranges and making their batch-produced series mar-
ketable. By generating substantial private orders, he also helped the
firms to prosper economically. For the *Dritte Deutsche Kunstgewerbe-
Ausstellung* (Third German Arts and Crafts Exhibition), in Dresden in
1906, van de Velde designed the museum hall with wall paintings by
Ludwig von Hofmann as an artistically complete and coherent whole.

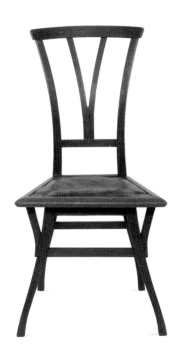

Henry van de Velde,
Bloemenwerf chair,
c.1898 (design 1894–95)

Henry van de Velde,
Cabinet for a library,
formerly owned by
Johanna and Herbert
Esche, Chemnitz,
1897–98, acquired
with support from
the Kulturstiftung
der Länder

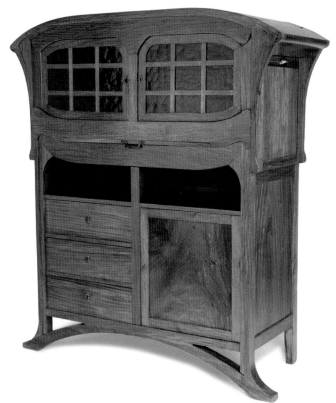

**93**

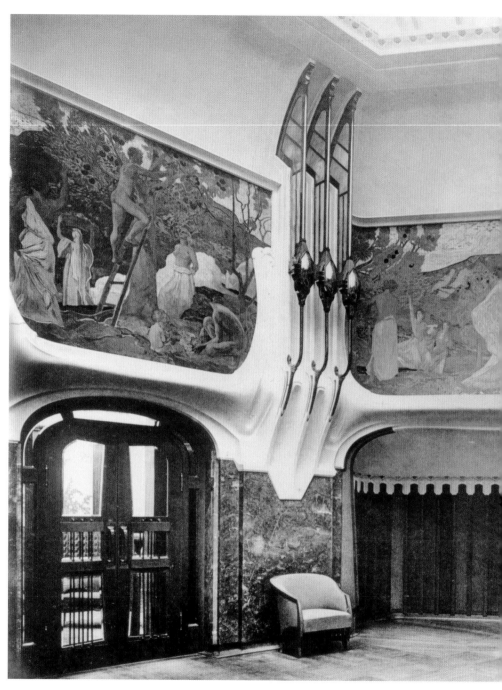

Henry van de Velde, Museum hall for the *Dritte Deutsche Kunstgewerbe-Ausstellung* (Third German Arts and Crafts Exhibition), Dresden, 1906. The architecture has not survived. Except for one lost painting, the murals by Ludwig von Hofmann are now in the possession of the Klassik Stiftung Weimar.

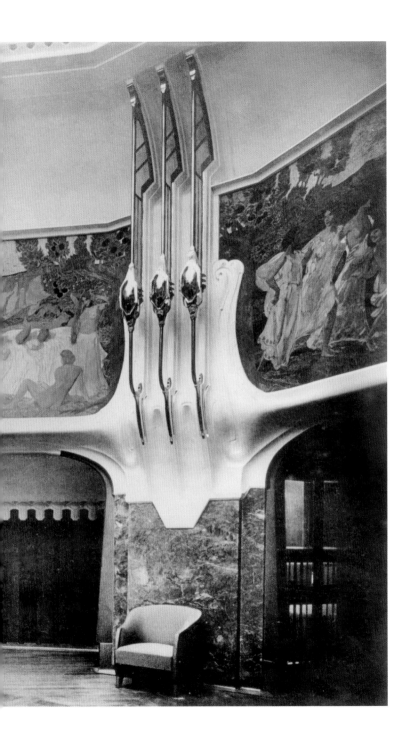

Furthermore, in the collective room for Weimar he presented a wide spectrum of his own arts and crafts designs for Thuringian producers: ceramics from Bürgel, Burgau, Volkstedt and Ilmenau; light fittings from Bad Berka and Altenburg; and furnishings, stoves, pianos, fans, leatherwork, belt buckles, textiles and glass works from Weimar. His presentation, moreover, included stoneware vessels from the Westerwald, decorative fabrics from Lunzenau, porcelain from Meissen and silverwork from Weimar and Bremen.

One of the outstanding pieces of the Weimar period is the magnificent wedding gift for Grand Duke Wilhelm Ernst and Grand Duchess Caroline, an opulent silver table service consisting of 250 pieces of cutlery, 56 plates and 47 hollowware objects. The Modell I cutlery series, in conjunction with van de Velde's exclusive Meissen porcelain, embodies the elegance of fully perfected form and therefore claims its place among the most popular Jugendstil silverware designs.

The qualities of solid workmanship, functionality and material-conscious production are just as distinctive in the furnishings van de Velde designed from 1902 on for production by the Weimar court

Henry van de Velde, Dining service made by the Royal Saxon Porcelain Factory Meissen, formerly owned by Johanna and Herbert Esche, Chemnitz, 1903–04, acquired with support from the Kulturstiftung der Länder

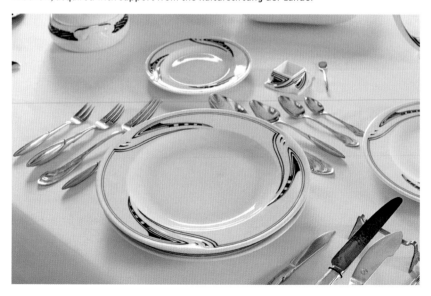

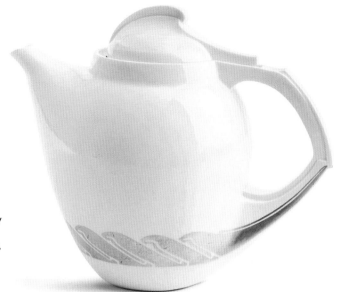

Henry van de Velde, Coffee pot made by the Royal Saxon Porcelain Factory Meissen, formerly owned by Johanna and Herbert Esche, Chemnitz, 1903–04, acquired with support from the Kulturstiftung der Länder

cabinetmaker Scheidemantel. He rejected floral and figurative decor as useless, adorning his chairs and tables instead with organic lines of force. He geared his work towards artisan craftsmanship produced in small batches and refrained from embarking on mass production. 'I could add nothing to the technically perfect execution of Scheidemantel's furniture', van de Velde commented in his *Denkschrift* (Memorial statement) in 1914: 'but through the pieces executed to my designs I at least did my utmost to ensure that they were known, appreciated and bought in Germany and abroad. The orders I have directed to the firm amount to 700,000 marks to date.'

Van de Velde's Weimar period is considered the most productive and successful phase of his artistic career. Besides his activity as artistic adviser and director of the Kunstgewerbeschule, in his private studio he designed a wealth of arts and crafts works that combine aesthetic design with craftsmanship of enduring value and hence achieve top prices at auction today.

# Henry van de Velde

## Asparagus server, model I, 1903

Acquired with support from the Kulturstiftung der Länder

On the elegantly formed asparagus server, the blade was curved upwards to prevent the asparagus from slipping off. The understated decoration of the obverse of the server consists of delicate linework. The asparagus server is part of the Modell I cutlery series and was first executed on 11 May 1903 for the grand ducal gift of silver. The item shown here was originally the property of Johanna and Herbert Esche of Chemnitz. AN

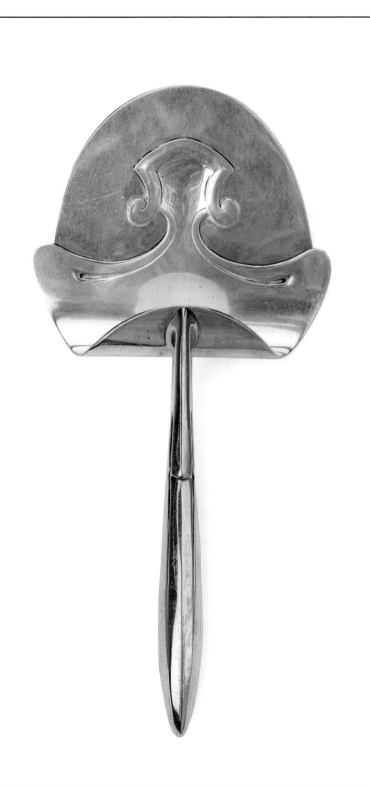

# VILLAS, MUSEUMS AND THEATRES

## Henry van de Velde as an architect in Central Germany

KILIAN JOST

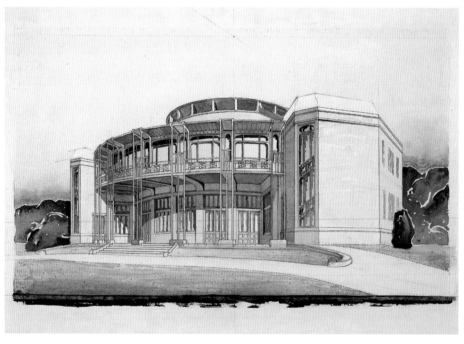

Henry van de Velde, Design for the Dumont-Theater in Weimar, 1903–04.
The design was not realised.

**BUILT IN 1895 NEAR BRUSSELS**, Bloemenwerf house was Henry van de Velde's first building and established his worldwide fame as an architect and designer. In collaboration with Octave van Rysselberghe, further buildings were realised in Brussels, for which he designed the interiors. It was first in Weimar that the trained painter was able to work more extensively as an architect. He found wealthy clients in what are today's federal states of Thuringia and Saxony, which explains why this area – as well as the city of Hagen, where van de Velde realised several buildings for his patron Karl Ernst Osthaus and his family circle – is where his most important buildings of this creative period were constructed.

Upon moving to Weimar, in April 1902, van de Velde was commissioned with the modification of the Nietzsche-Archiv. For the historical villa that was Elisabeth Förster-Nietzsche's residence, he designed an imposing porch and the public archive rooms on the ground floor. The central library and collection room is a rare testimony to van de Velde's architectural skill and has been preserved in every detail to this day as a fascinating *Gesamtkunstwerk* (total work of art).

Shortly after being appointed, van de Velde received two public commissions in Weimar: one for the new Grossherzoglich Sächsische Kunstschule Weimar (Grand Ducal Saxon Art School) and the other for the Grossherzoglich Sächsische Kunstgewerbeschule Weimar (Grand Ducal Saxon School of Arts and Crafts), of which he was the founder. The plans were submitted as early as 1904, but the projects' realisation progressed haltingly and extended over four phases of construction. While van de Velde was able to finish the smaller project, the Kunstgewerbeschule, in 1906, the art school building was only completed in 1911. Planned from the outset as an architectural ensemble, the school complex housed the Staatliche Bauhaus Weimar

(Weimar State Bauhaus) from 1919 and has been part of UNESCO World Cultural Heritage since 1996.

By 1904, while work on the school buildings was still in progress, van de Velde also delivered plans and models for the construction of the new Grossherzogliche Museum für Kunst und Kunstgewerbe (Grand Ducal Museum of Arts and Crafts) on modern-day Goetheplatz, for which Count Harry Kessler had developed an architectural scheme even before taking up his post as museum director. Van de Velde was required to integrate both the translocated Venetian palace façade, belonging to the old building, and the existing Skylight Hall. But the grand duke withdrew his approval before realisation could begin. Designs submitted in 1908 for the extension of the Grossherzogliche Museum (Grand Ducal Museum) in Weimar, today's Neues Museum Weimar, and in 1913–14 a central museum for Thuringia in the Erfurt city park ended in similar disappointment. Of the planned museums, van de Velde was able to realise only the comprehensive interior design of the Folkwang Museum in Hagen (1902). His working relationships with private clients were more successful by far. In Chemnitz he realised the Lawn Tennis Club and grounds (1908),

Henry van de Velde, Design for a new building for the Grossherzogliche Museum für Kunst und Kunstgewerbe in Weimar, view from the street known today as Karl-Liebknecht-Strasse, 1903-04. The design was not realised.

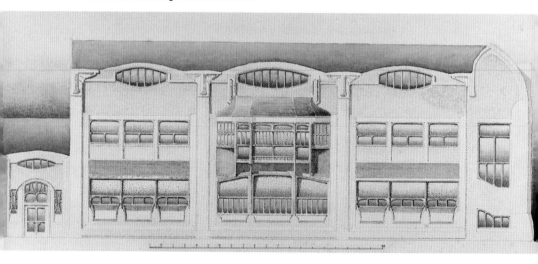

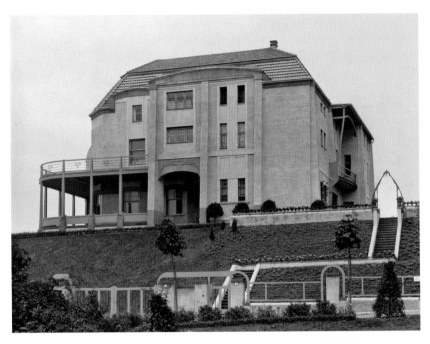

Henry van de Velde, Villa of Johanna and Herbert Esche in Chemnitz, 1902–03, photo c.1903. Today the villa is a museum and open to visitors.

the Haus Esche (1902–11) and Haus Körner (1914), while in Jena he was responsible for the Ernst Abbe monument (1911). In Weimar he was commissioned with the Palais Dürckheim (1913) and the Haus Henneberg (1914), followed by the generously appointed Haus Schulenburg, in Gera in 1914. His own residence, Haus Hohe Pappeln (1907–08), was designed as a programmatic statement and lays claim to special status among the other private homes built.

Enthusiastically as ever, van de Velde turned to the theatre as a new architectural challenge. His first design was a summer theatre for the actress Louise Dumont, who planned a 'national dramatic theatre' for Weimar. Its envisaged purpose was to support the establishment of a festival during the summer months, based on the model of Bayreuth. Van de Velde proposed revolutionary innovations in 1903, doing away with the conventional stage area as well as the amphitheatre favoured by Richard Wagner. He strove for an auditorium without tiers, boxes or a proscenium, with the best possible view from every

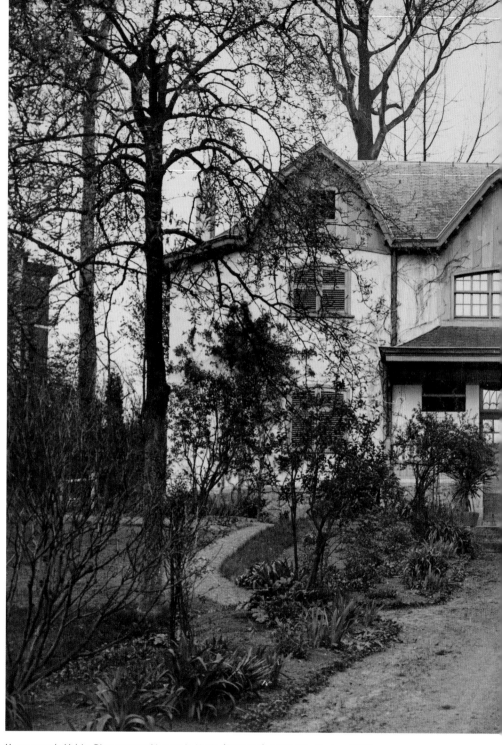

Henry van de Velde, Bloemenwerf house in Uccle (Brussels), 1894–95, photo c.1897.
Today the house is privately owned.

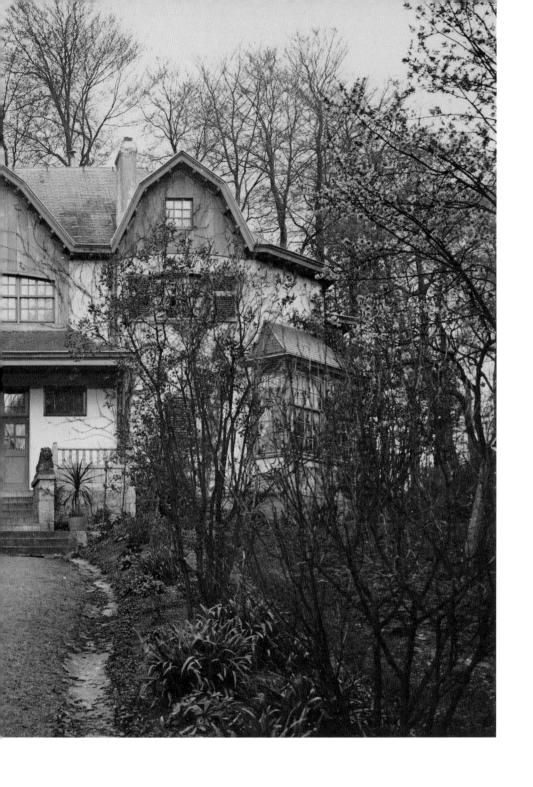

Henry van de Velde, Monument to the physicist and social reformer Ernst Abbe in Jena, 1909–11, photo: Louis Held, 1911. The monument is accessible to the public.

Henry van de Velde, Villa Schulenburg in Gera, 1913–14, photo: Louis Held, c.1914.
Today the villa is a museum and open to visitors.

seat. He embraced the recently developed idea of a rounded horizon and came up with an innovative three-section stage that enabled rapid scene changes without alterations or a revolving stage. The implementation of his design was fought from many quarters and came to nothing. Nevertheless, van de Velde's design kindled the interest of the theatre reformers Edward Gordon Craig and Max Reinhardt, who were thus prompted to travel to Weimar. In 1910 van de Velde was commissioned with the building of the Théâtre des Champs-Élysées in Paris.

Henry van de Velde, Design for the Théâtre de Champs-Elysées in Paris, 1910–11.
The design was realised in a substantially modified form by Auguste Perret.

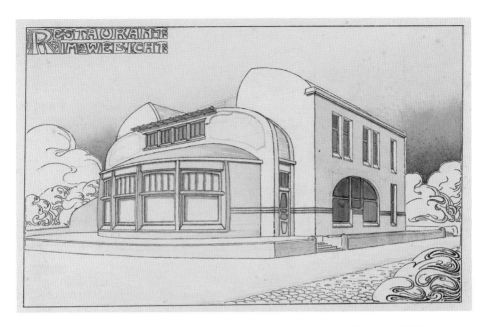

Henry van de Velde, Design for a restaurant in the Webicht woodland near Weimar, 1903–04. The design was not realised.

He proceeded to design its large auditorium without proscenium boxes and with a three-section stage. Auguste Perret executed the altered design alone in 1913 and was henceforth considered its author.

Van de Velde's crowning achievement in theatre design is the large theatre built in 1914 for the first full-scale exhibition by the Deutsche Werkbund (German Association of Craftsmen) in Cologne. His Werkbund Theater was acknowledged as the high point of the exhibition, along with the Musterfabrik (Model Factory) by Walter Gropius and Bruno Taut's Glashaus.

In Weimar, several of van de Velde's projects remained unrealised. Apart from the designs already mentioned for the two museums and for the Dumont-Theater, the restaurant in the Webicht woodland, the Nietzsche stadium and the Hoftheater were cancelled. Van de Velde's departure from Germany in 1917 amid tensions arising during the Second World War marked the end of his most important phase as an architect.

## Henry van de Velde

## Haus Hohe Pappeln in Weimar, photo: Louis Held, 1912

Today the Haus Hohe Pappeln is a museum and open to visitors.

Henry van de Velde designed Haus Hohe Pappeln, in Ehringsdorf in the south of Weimar, in 1907 as a home for his family of seven. After Count Harry Kessler had resigned as museum director, van de Velde demonstrated his resolve to stay in Weimar by building this residence. Rather than a villa with a regimented, imposing façade, however, he designed it as a simple country house. Since his attention was primarily on use, he designed the dwelling like all his buildings, from the inside outwards. An open ground plan and coherent sequencing of spaces resulted in an asymmetrical façade. With the polygonal form of both the ground plan and the roof covering, van de Velde created an organic overall effect of well-balanced harmony. Balconies and the surrounding southern terrace reinforce the link with the garden, while the hipped roof with its plunging eaves conveys a sense of security. Compared with the residential designs produced for his clients, Haus Hohe Pappeln represents van de Velde's most idiosyncratic solution for a private home. KJ

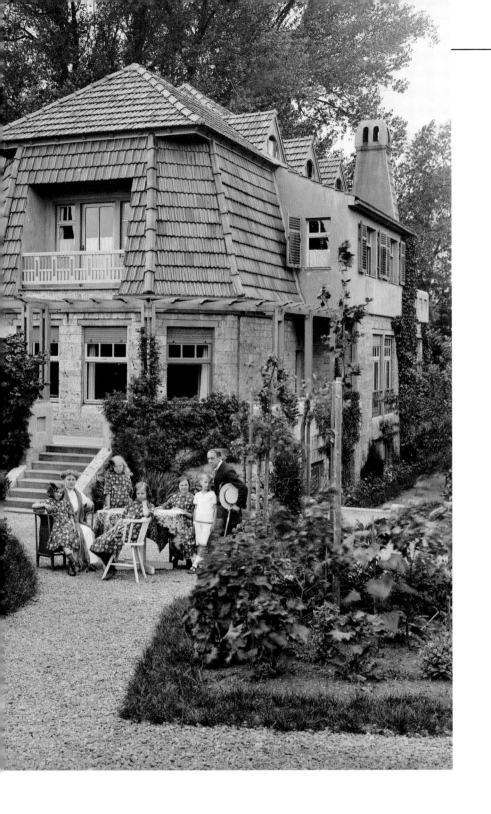

# LIFE REFORM
## New styles as an intellectual stance

MARTINA ULLRICH

Alkoholfreies Restaurant
Bachs Luftbad

Wolfgang Bach's
abstinence restaurant
and air bath,
Weimar c.1910

AROUND 1900, there was not only a spirit of change in the air but also a fear of the future. In the wake of industrialisation, technological progress in particular was advancing at phenomenal speed. The pace of life in the growing cities seemed to be escalating to a previously unknown pitch. This brought forth critics advocating different alternative approaches to counter the acceleration in people's lives. All these renewal endeavours are referred to collectively as the 'life reform' movement.

From that time onwards, living in harmony with nature instead of continuing to subjugate it was deemed the ideal state of being. Raw food and occultism also attracted enthusiastic followers. Enhancing health became the subject of countless contentious discussions. Thorough hygiene and abstinence from alcohol and meat were discovered as wholesome pursuits. For the first time outside of military training, physical exercise was practised outdoors in the fresh air. Physicians and naturopaths such as Friedrich Eduard Bilz and Heinrich Lahmann were keen to restore the affluent population to full health by means of sanatoriums and 'air baths'. Even Weimar was graced with such an air bath, including a restaurant for abstinent diners.

Self-appointed itinerant preachers and apostles of nature such as Karl Wilhelm Diefenbach and Gustav Nagel travelled up and down the country – derided and admired in equal measure – giving speeches about their reformist beliefs, addressing such matters as healthy living or even phonic writing.

In Switzerland, on a hill above Ascona, the Monte Veritá was established. Part-commune and part-artists' community, this 'Mount of Truth' became a place of pilgrimage for life reformers.

Friedrich Nietzsche's provocative writings and the mystical depictions of nature by the artist Hugo Höppener, known as Fidus,

The itinerant preacher Gustav Nagel, Weimar, photo: Louis Held, 1901

Alfred Soder, *Naked Nietzsche in the High Mountains*. Bookplate for Friedrich Berthold Sutter, c.1907

left their mark on the missionary zeitgeist. Under these influences, the works of many avant-garde artists, such as Sascha Schneider or Ludwig von Hofmann, revered the new cult of youth.

Despite the conceptual similarities among the many reformist tendencies, completely divergent intellectual stances emerged. Some followers of the body and health cult aimed at developing a peaceful, closer and holistic relationship with the nature they had believed lost; others perverted these ideas into a racist, anti-Semitic interpretation, which was adopted in turn by the National Socialists.

Reformist ideas infused many spheres of life, from food and housing to sex and religion. The old-established rules of dress for women and men were perceived as a harmful constraint, as indeed was the latest fashion. Even conventional footwear was scorned as deforming and became the subject of written treatises. The commonly worn

Hugo Höppener (known as Fidus), *Prayer to the Light*, 1894

Ludwig von Hofmann, *Women Dancing*, 1906. The painting was part of a cycle in the museum hall designed by Henry van de Velde at the *Dritte Deutsche Kunstgewerbe-Ausstellung*, Dresden, 1906

corset was now deemed to be a health hazard. With heavy nationalistic undertones at times, 'French fashion' was demonised in Germany, and liberation from tightly-laced underwear was demanded by and for women. A prominent campaigner against the corset was the controversial painter and architect Paul Schultze-Naumburg. As a layperson with no medical training, this rival of Henry van de Velde's argued vehemently for the abolition of the corset and made recommendations for clothing more appropriate to the body. He later became a Nazi functionary and fought an acrimonious battle against the Bauhaus and functional modernism.

Numerous artists and designers such as Peter Behrens, Alfred Mohrbutter, Gustav Klimt, Koloman Moser and Joseph Maria Olbrich turned their attention to the anti-fashion of the reform dress and created artists' dresses, mainly for their partners and wealthy female

clients. Some women designed artistic reform dresses themselves with equal success. Especially well known are the works of Margarethe von Brauchitsch, Anna Muthesius and Else Oppler. Van de Velde, on purely aesthetic grounds, was another advocate of 'Das neue Kunst-Prinzip in der modernen Frauen-Kleidung' (The new art principle in modern women's clothing). In an eponymous article published in 1902 in the journal *Deutsche Kunst und Dekoration*, he proclaimed his motivation for supporting the cause, for 'the German clothing reformers committed ... the error that they paid no regard to aesthetic sense'.

Maria van de Velde supported her husband in many different ways and influenced him in his work. A trained pianist, she was considered his motor. She provided crucial impulses for his artistic response to the English Arts and Crafts movement. Even the design of their first home – Bloemenwerf house, in Uccle near Brussels – was a joint undertaking. On textile and clothing designs, too, Maria and Henry van de Velde worked hand in hand. She was directly

Demonstration of the dangers of the corset for the human body, in Heinrich Lahmann, *Die Reform der Kleidung* (Stuttgart, 1898).

Maria van de Velde
in the studio of
Bloemenwerf house,
c.1898

involved in the fabrication of numerous items. She was photographed
in various everyday situations wearing the dresses on which they had
collaborated and presented herself as a model and a modern woman.
Their five children were raised unbaptised, anti-authoritarian, close
to nature and without social constraints in Weimar. Despite Henry
van de Velde's middle-class background and illustrious social con-
nections, not only his design oeuvre but also his family's lifestyle was
clearly shaped by ideas of reform.

Henry and Maria van de Velde with their children in the vestibule
of Haus Hohe Pappeln, Weimar, photo: Louis Held, 1912

**Maria van de Velde in a tea gown, *c.*1896 (design), and detail of the replica shown in the exhibition, 2019**

The tea gown for grand occasions is a joint work by Henry van de Velde and Maria van de Velde. The ornamental embroideries with which the collar, sleeve and hem are trimmed were designed by him. She, working with a seamstress, took charge of the realisation. The wide-cut waist allows the wearer to decide for herself whether she wishes to wear a corset. The gown was made specifically for Maria and was one of her favourites. More than likely for that reason, it is one of the most frequently pictured morning dresses by van de Veldes. MU

# THE CLIENTS

## Who lived in the interiors designed by Henry van de Velde?

THOMAS FÖHL

Henry van de Velde, Chair,
formerly owned by the Wolff
family, 1908 (design 1906)

**IN HIS DECISION TO TURN** to the arts and crafts and interior design in 1892, Henry van de Velde made a clean break from his past as a trained painter, and with it, the 'fine arts'. During his life he rejected the opportunity to have his furniture industrially produced in series, but he did welcome machine work under technically improved conditions. In the German arts and literary magazine *Pan* in 1898, he explained:

'My furniture emphasises the fact that it is made of wood; I let every joint show with pride and joy and look for new ways to join piece to piece. For me, it is a kind of honesty and a protest against timeworn taste that can no longer tell the difference between wood and metal or cardboard.'

Van de Velde always tried to create interior designs that matched the circumstances of the surroundings and above all, the needs of his clients. The only exceptions occurred when clients with whom he was not closely acquainted commissioned him to design individual rooms based on furnishings they had seen in exhibitions, publications or other people's homes.

The two interiors on display in the Neue Museum illustrate this process quite vividly when we analyse their historical circumstances and origins. We can study the apartments van de Velde designed for Max von Münchhausen and Alfred Wolff, since a sufficient number of contemporaneous illustrations and items of correspondence still exist. It is important to bear in mind, however, that we can only gain a vague idea of the effect of individual pieces of furniture and ensembles outside the context of the rooms for which they were designed. How van de Velde's *Raumkunstwerke*, or spatial works of art, appeared in their original composition, how they interacted with the colour schemes of the rooms, the stucco ceilings, textile-covered walls, curtains and individually designed carpets and lamps, as well

Max and Editha von Münch-
hausen, photo: Atelier Elvira,
Munich, 1904

Ladies' drawing room in the
Münchhausen apartment at
Cranachstrasse 1b, Weimar,
photo: Louis Held, 1904

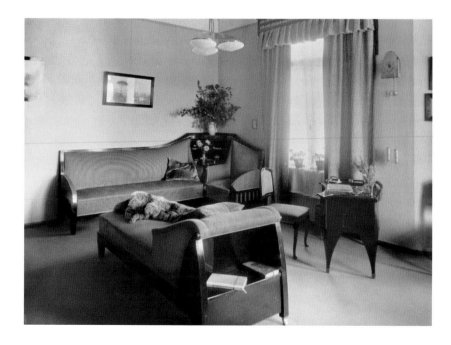

Hanna and
Alfred Wolff in
Karnak, 1905

as the paintings occasionally chosen specifically for these rooms – all
this is left to the viewer's imagination.

The journalist and playwright Max Freiherr von Münchhausen
had cultivated a relationship with the Nietzsche-Archiv beginning
in 1900. He had planned to move from Berlin to Weimar in 1903,
even before his marriage to Editha Müller von Schönaich. By grant-
ing a commission to van de Velde, he hoped to further strengthen
his ties to the Nietzsche-Archiv and the leading figures associated
with the New Weimar. He regarded his future apartment at Cranach-
strasse 1b as a ticket to this illustrious circle. At the same time, he
complained in his letters to Elisabeth Förster-Nietzsche about the
exorbitant price of the furniture and repeatedly expressed his rather
low opinion of Count Harry Kessler and the Belgian artist. His stay in
Weimar was consequently a rather brief episode, lasting until 1907.
The extensive furnishings ultimately found their way to Florence
in 1913.

Maurice Denis,
*La treille* (The Vine
Bower), formerly
owned by the
Wolff family, 1905,
permanent loan from
a private collection

The banker Dr Alfred Wolff became van de Velde's client in 1905, when he commissioned the architect to design his opulent apartment on Karolinenplatz in Munich. In this case, van de Velde's steep prices played only a minor role. The residential ensemble was celebrated among mutual friends as the culmination of the artist's oeuvre. The apartment was not yet finished when Wolff was appointed chairman of the Deutsche Bank in Berlin, in 1907. The publisher Hugo Bruckmann moved into the almost completely furnished apartment while van de Velde began designing the interior of Wolff's spacious one-floor apartment on Pariser Platz, prominently situated next to Max Liebermann's townhouse at Brandenburg Gate. The luxurious dining room furniture derives from this ensemble, along with a painting by Maurice Denis that van de Velde had advised Wolff to purchase for his Munich salon on Karolinenplatz.

The two apartments for the Wolff family, in Munich and Berlin, were followed by one last commission, in 1912, when the banker

returned to Munich. He instructed van de Velde to integrate the furnishings of his Berlin apartment into his new residence. By this time the two men had become closer friends. They wrote and visited each other, whereby records show that before van de Velde came to visit, the Wolffs made sure that every single detail of the perfectly arranged rooms was 'put in order' so as not to upset the 'master'. This also applied to certain paintings, such as the portraits of Hanna Wolff and their daughter Marcella painted by their artist friend Franz von Stuck. Van de Velde rigorously rejected Stuck's works, so that the portraits had to be temporarily removed from the walls.

Van de Velde enjoyed an even closer relationship with the Berlin painter Curt Herrmann and his wife, Sophie, his first German customers, who commissioned him to design their apartment in 1897. A second commission, to create the interior furnishings for an even larger apartment in Charlottenburg, followed in 1911. Herrmann's mother-in-law, Lina Herz, was also one of the Belgian's loyal customers. Both Herrmann and Lina Herz supported their mutual friend several times by lending him money with very friendly terms. The enormous influence van de Velde had on his clients in matters of taste and in his role

Henry van de Velde, Side cabinet, formerly owned by the Herrmann family, 1897-98, permanent loan from the Ernst von Siemens Kunststiftung

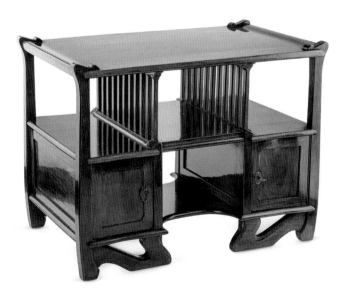

as artistic advisor in creating their art collections is substantiated by numerous documents, preserved in their respective estates. Our knowledge about the circumstances and expenses, as well as the conflicts and reciprocal support offered in times of need is far larger in van de Velde's case than with other designers, as many of his clients kept records out of a sense of piety and appreciation.

This is impressively demonstrated by two pieces of furniture, the first a small side cabinet, from 1898, and the other a painting cabinet, from 1900, both of which were installed in the Herrmanns' first Berlin apartment. The latter was made exclusively for Curt Herrmann, whom van de Velde had been encouraging to do more pastel painting. Their many letters document the keen interest with which both artists and their wives kept abreast of the latest modernist trends and how Curt Herrmann's remarkable style developed under the Belgian's influence. The side cabinet, on the other hand, which is likewise made of exotic padauk wood, was purchased in the mid-1920s by Eduard Plietzsch, who had been friends with the Herrmanns and van de Velde since 1910. The fact that people were starting to actively collect furniture made around 1900 was a completely new

Henry van de Velde, Painter's cabinet, formerly owned by Atelier Curt Herrmann, permanent loan from the Curt Herrmann Heritage Foundation

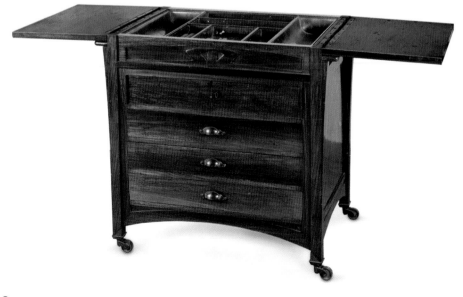

Curt Herrmann,
*Spring Flowers
in the Garden*, c.1903,
permanent loan from
the Curt Herrmann
Heritage Foundation

phenomenon at that time, and there is no evidence that it applied to any other designer of the period. In addition to Plietzsch, other collectors included the Chemnitz industrialist Herbert Esche and the Weimar sculptor Richard Engelmann. Plietzsch had worked at several museums before becoming an art dealer after the First World War. In his memoires he proudly recounts that in the apartment he took over from Walter Gropius at the Berlin Tiergarten, he preserved three rooms by the leading exponents of modernism in Weimar: an early dining room designed by van de Velde, a salon by Gropius and a study by Otto Bartning.

# Henry van de Velde

## Corner sofa, formerly owned by the Münchhausen family, 1904

Acquired with support from the Kulturstiftung der Länder, the Freistaat of Thuringia and the Federal Government Commissioner for Culture and the Media

In 1904 Henry van de Velde designed five rooms in Max von Münchhausen's new Weimar apartment. The centrepiece was a lady's salon with a corner sofa, table, elegant chairs, a chaise longue and a lady's writing

desk. The intimate corner sofa and Editha von Münchhausen's chaise longue are elegantly designed without appearing pretentious. The artist also paid close attention to aspects of functionality. For example, both pieces of furniture contain a niche for books and the corner sofa includes a space for a decorative vase. Van de Velde's belief in 'reasonable' design is evident in his choice of upholstery. He used a broad-ribbed chenille of a colour that harmonised with the furniture's dark-red mahogany. TF

# MODERN SPACES
## The avant-garde designs in the New Style

KILIAN JOST

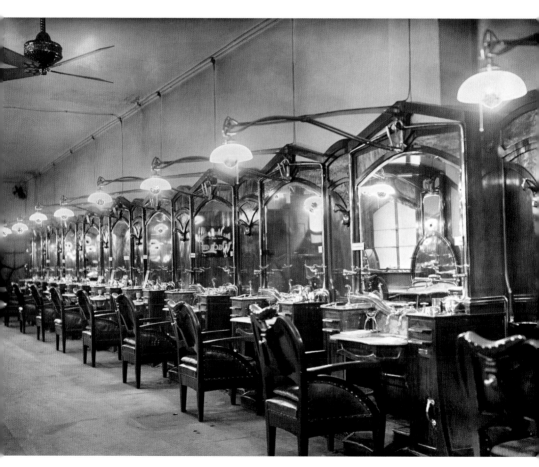

The François Haby hairdressing salon in Berlin, men's department, interior design and furnishings by Henry van de Velde, 1901, photo taken after electrification, c.1910

**FROM THE START OF HIS DESIGN CAREER**, Henry van de Velde created rooms and spaces imbued with unprecedented modernity. For galleries and the Tropon company, these works and the attention they generated were key to a successful corporate presentation. François Haby's hairdressing salon in Berlin, designed by van de Velde in 1901, was a spectacular highlight in his oeuvre, but certainly not the first.

The galleries L'Art Nouveau and La Maison Moderne, in Paris were adept at making the most of the designer's attention-grabbing creations. The art gallery Maison de l'Art Nouveau opened in Paris in 1895; its owner, Samuel Bing, had commissioned the architects Louis Bonnier and Victor Horta to convert a residential building at 22, rue de Provence for this purpose. Van de Velde was responsible for designing four model living spaces in the gallery. The commission – the largest van de Velde had ever landed up to that point – included a small salon made of satinwood, a rotunda, a dining room of cedar and a smoking room of padauk. The rooms were to be used for presenting arts and crafts by various avant-garde artists from all over Europe. Unfortunately, the first exhibition devolved into a scandal. Van de Velde himself supplied the fodder for controversy by describing his design as the 'Yachting Style'. Auguste Rodin even disparaged him as a 'barbarian'. Though his debut as a designer ended in crushing defeat, one could regard the passionate rejection of van de Velde's work, in hindsight, as a distinction of merit. Bing's Maison de l'Art Nouveau became the eponym for a new modern style in France. In 1897 Bing presented the same items at the *International Exhibition of Fine Arts* in Dresden. In addition to the four rooms described above, van de Velde also designed a recreation room. In contrast to his reception in Paris, the show in Dresden received an overwhelmingly positive response from the public and critics alike. The exhibition contributed

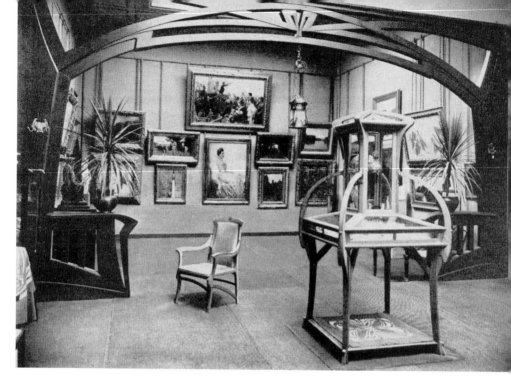

Exhibition of the Munich Secession in 1899, interior design and furnishings by Henry van de Velde

significantly to van de Velde's reputation in Germany and resulted in numerous commissions.

In 1899 the art critic Julius Meier-Graefe opened La Maison Moderne in Paris in direct competition with Maison de l'Art Nouveau. Van de Velde designed the store front, the vitrines, shelves and examples of model living spaces. He also designed two galleries in Berlin with similar pioneering spirit. In 1897 the art salon Keller und Reiner at Potsdamerstrasse 122 began selling modern arts and crafts in Germany, and the following year, the Galerie Cassirer offered works of French Impressionism in Germany for the first time. For Keller und Reiner, Alfred Messel was tasked with creating the skylight room for paintings, while van de Velde was asked to design the 'modern hall for the arts and crafts'. The Galerie Cassirer on Viktoriastrasse commissioned van de Velde to create an elegant reading room and skylight room. In the years after Paul Cassirer assumed sole management of the company, in 1901, the gallery became one of the top addresses

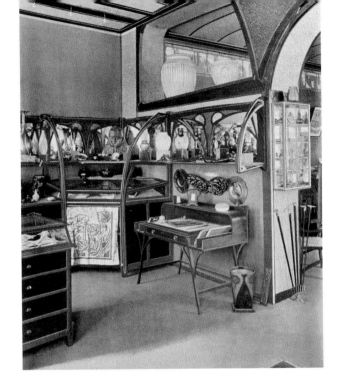

Galerie La Maison
Moderne, Paris,
interior design and
furnishings by Henry
van de Velde, 1899

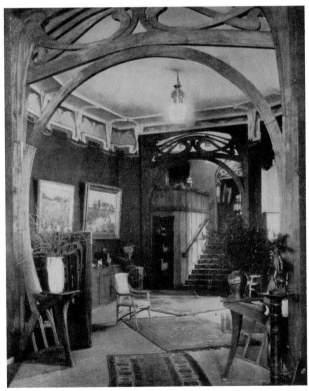

Galerie Keller und Reiner
in Berlin, interior design
and furnishings by Henry
van de Velde, 1897

for modern art in Europe. A third important gallery in Berlin was the Hohenzollern-Kunstgewerbehaus (Hohenzollern Arts and Crafts House), which had been established in 1879. For their new headquarters, contemporary artists were commissioned to design the interior, including Josef Hoffmann and Max Läuger. Van de Velde was responsible for designing most of the sales rooms, the storefront to Leipziger Strasse, the entrance hall and the staircase.

Besides galleries, companies also commissioned van de Velde to present them as modern, progressive enterprises. In 1897 the entrepreneur Eberhard von Bodenhausen started ordering posters, advertisements and labels for a new product called 'Tropon', a nutritional protein supplement that served as an inexpensive meat substitute. In effect, van de Velde developed the first uniform company presentation in the sense of a modern corporate design. The Continental Havana-Compagnie also commissioned him to design their Berlin headquarters in 1899. He furnished the offices located at Mohrenstrasse 11/12 with graceful doorframes and glass display cases for

Hohenzollern-Kunstgewerbehaus in Berlin, interior design and furnishings by Henry van de Velde, 1901

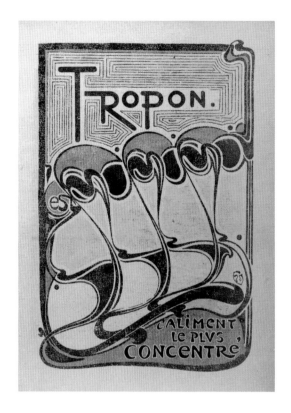

Henry van de Velde, Poster advertising the firm Tropon, 1898, private collection

their tobacco products. An elegant ornamental frieze in the form of stylised cigar smoke decorated the wall edge.

To project a modern image, companies, especially those marketing 'new products', enlisted the services of spectacular designers. Van de Velde fit the mould perfectly. His gallery venues and shop rooms were characterised by seating furniture based on his older designs, as well as exquisite vitrines, sophisticated wainscoting and especially lintels and passageways with dynamic wood constructions. Using these elements, van de Velde achieved organic room designs with an elegantly uplifting effect.

François Haby, too, demonstrated his business prowess when he commissioned the Belgian shortly after his arrival in Berlin. As the court barber to the German emperor, Haby marketed beard grooming products and influenced fashion trends in the empire. The interior design of his Berlin salon at Mittelstrasse 7 became a

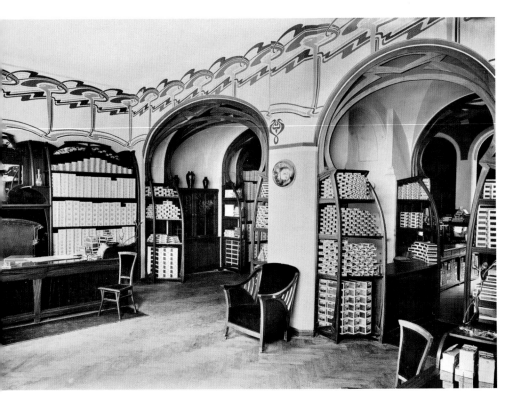

Headquarters of the Continental Havana-Compagnie in Berlin, interior design and furnishings by Henry van de Velde, 1899

sensational news story. His hairdressing salon was soon the topic not only of advertisements and gossip columns but also among art critics. Heinrich Mann even mentioned him in his 1918 satirical novel *Der Untertan* (published in English as *Man of Straw*). The audacity of the design lay in van de Velde's decision to leave the brass gas and water lines exposed for decorative purposes. But the capital of the German Empire was certainly no cakewalk for modern art and architecture. Emperor Wilhelm II was resolutely opposed to the avant-garde. He derided Count Harry Kessler as an 'oddball' and complained that van de Velde's interiors made him 'seasick'. Even Max Liebermann, the undisputed leader of the Berlin Secession, criticised Haby's salon with reference to the exposed piping. For after all, he didn't 'wear his entrails like jewellery around his neck either.'

A more provincial environment promised refuge and greater opportunities. Moving to Weimar and assuming influential positions offered both Kessler and van de Velde new artistic freedoms which they enthusiastically made use of. It was in Weimar that Kessler managed to establish the Deutsche Künstlerbund in 1903. The fractured German Secession movement could once again unite under the aegis of one institution which served as a bulwark against the monarchy's interference in artistic matters. For a man like van de Velde, who lacked commercial talent, Weimar offered the financial security that he and his growing family needed. He created spaces of modern life far away from the imperial capital, such as the clubhouse and entrance building of the Chemnitz Lawn Tennis Club in 1908. Tennis was a relatively new sport in Germany at the time; the German Tennis Association had been founded just six years earlier, in 1902. Van de Velde and his New Style seemed predestined for a building project for which there were no models or prototypes.

Chemnitz Lawn Tennis Club, architecture and interiors by Henry van de Velde, c.1908

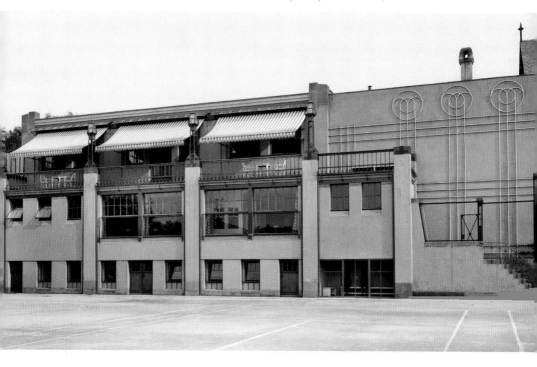

## Henry van de Velde

## Compartment from the François Haby hairdressing salon, Berlin, 1901

Almost all of Henry van de Velde's spectacular interior designs have been lost to posterity. Yet, one of his Berlin masterpieces, this hairdressing station created for Haby's salon, still exists today. The arrangement of twelve compartments for men and seven for women produced an exquisite atmosphere characterised by reddish mahogany, green marble wash basins and a violet wall frieze. The brass water and gas connections were laid bare in front of the furniture as decorative elements – something contemporaries found strange and radical. In hindsight, van de Velde admitted that the idea had been a mistake. Art critics, however, encouraged their readers to visit the salon as an 'attraction of the imperial capital'. ᴋᴊ

# THE COMPETITION OF NEW STYLES
## The Werkbund dispute

KILIAN JOST

Karl Arnold, Caricature of the Werkbund exhibition, from *Simplicissimus*, 3 Aug. 1914

**THE UBIQUITY OF MODERN DESIGN** outside of elite circles would be inconceivable without the Deutsche Werkbund. The association was founded in 1907 by a group of artists and entrepreneurs. Henry van de Velde considered himself the intellectual father of the Werkbund, as implied in the second part of the 'Kunstgewerblichen Laienpredigten' (Arts and Crafts layperson's sermons) he wrote in 1907: 'It may be a bold suggestion to demand that each and every one of us, Behrens, Albin Müller, Olbrich, Pankok, Riemerschmid and van de Velde, acknowledge and study the works of others, and that each should appreciate and embrace the good characteristics of his comrades-in-arms – for we should all view each other rather as comrades-in-arms than adversaries.'

In the above, van de Velde mentioned key figures in an uprising which first took form around 1890. These were individuals, mainly artists, who rebelled against what they viewed as the negative effects of industrialisation on the arts and crafts. They denounced historicism and its imitation of the styles of the past, which they felt had been reduced to mere ornamentation on industrial goods. Across the European continent, counter-movements began – in Brussels, Darmstadt, Glasgow, Munich, Nancy, Vienna and Weimar. The local variants of what van de Velde described as the New Style were by no means homogenous. The individual names of these movements still underscore their differences to this day: Jugendstil, École de Nancy, Modern Style, Art Nouveau and the Secession style. For despite their common purpose of establishing a modern design, they possessed a broad range of forms – from exotically floral to stringently geometric, from handcrafted, one-of-a-kind creations to serial manufacturing. In addition to strictly rejecting historicism and rallying around the cause of artistic renewal, they all have one essential characteristic in common. Based on the model of the English Arts and Crafts

Josef Hoffmann, Armchair
model no. 670 (Sitting
Machine), c.1905 (design)

Michael Thonet, Chair
no. 14, 1859 (design)

Charles Rennie
Mackintosh, Armchair
for the Argyle Street Tea
Room in Glasgow, 1897

movement and its most influential figure, William Morris, the new European movements all strived to merge the fine and applied arts.

While the Glasgow School and its most prominent representative, Charles Rennie Mackintosh, remained true to the Arts and Crafts movement, the École de Nancy advocated handcrafted production, but developed a floral style of its own. Motifs like thistles, dragonflies and other forms in nature adorned the etched, flashed glassware of Émile Gallé, René Lalique and the Daum brothers. The pieces by Josef Hoffmann, on the other hand, stood in stark contrast to this floral character. The architect and designer influenced the Viennese Jugendstil. Together with Joseph Maria Olbrich, he established the Wiener Secession (Vienna Secession) in 1897, and with Koloman Moser, founded the Wiener Werkstätte (Vienna Workshops) in 1903, which produced many of his geometric designs. One of his most famous is the *Sitzmaschine* (Sitting Machine).

The Darmstadt artists' colony was established in 1899. Thanks to the support of Grand Duke Ernst Ludwig of Hesse and by Rhine, a number of artists, such as Peter Behrens, Rudolf Bosselt, Hans

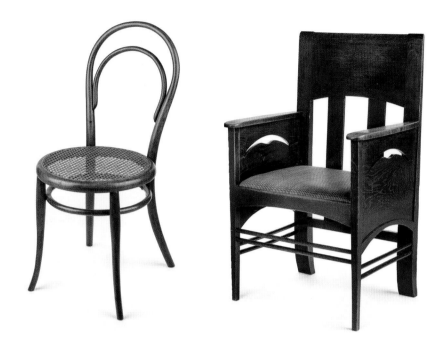

Christiansen and Joseph Maria Olbrich, went to Darmstadt for the chance to develop new forms of construction and promote the arts and crafts. With the appointment of van de Velde to Weimar in 1901, Grand Duke Wilhelm Ernst also hoped to economically revitalise his state by promoting the arts and crafts.

The idealisation of handcrafted production arose from a rejection of contemporary industrial products, but it wasn't the only alternative. Some artists and companies tried to develop modern products for serial manufacturing. A pioneer in this area was Michael Thonet, who had already developed a process for manufacturing bentwood furniture in 1836. In Vienna he founded the Gebrüder Thonet company. His Chair no. 14 became a global success in 1859 as it could be industrially manufactured and transported in pieces. Today it is still one of the most frequently produced pieces of seating furniture in the world and one of the most successful industrial products ever. The designers Richard Riemerschmid and Behrens, both – like van de Velde – professionally trained painters, also recognised the advantages of artistic designs for serial, industrial production.

Richard Riemerschmid, Wardrobe (from the Machine Furniture series), 1905 (design)

While Riemerschmid began designing his 'machine furniture' in 1903, Behrens was hired as an artistic advisor to the Allgemeine Elektrici-täts-Gesellschaft (AEG; General Electricity Association) in Berlin in 1907. As a universal designer of buildings, print materials, stationery and numerous products sold by AEG, Behrens was truly a pioneer of industrial design. Other companies like Waechtersbach also worked closely with artists. Their role became increasingly important: the age of the 'brand designer' had arrived.

The Deutsche Werkbund – as a consortium of artists and manu-facturers – aimed at developing designs that were oriented to the pur-pose, material and construction of the respective products. Its mem-bers included some of the most prestigious designers and architects of the time, including Behrens, Hoffmann and Riemerschmid. Van de Velde and Count Harry Kessler also joined the Werkbund, where they met Walter Gropius.

The influence of the Werkbund dramatically increased with the first Deutsche Werkbund exhibition, in Cologne in 1914. The

Emile Gallé,
Three vases, c.1900

Henry van de Velde, Theatre for the Werkbund exhibition in Cologne, with fountain by Georg Kolbe, 1914

exhibition presented buildings and consumer goods, all of which were distinguished by a modern design and exquisite quality. Visitors were especially taken with Bruno Taut's Glass House, van de Velde's central Werkbund Theatre and Gropius's Model Factory. For the first time, the term 'German workmanship' was propagated as a seal of quality.

Following the exhibition, a heated debate erupted at the seventh annual meeting of the Werkbund regarding the goals and ideology of the association. The leading figures in this so-called *Werkbundstreit* (Werkbund dispute) were the architect Hermann Muthesius and van de Velde. In his presentation, Muthesius introduced ten guiding principles for the future of the Werkbund. He called for a 'typification' of goods to make low-cost, mass production possible. Goods produced in large quantities would serve to increase German exports and conquer the global market.

Van de Velde spontaneously fired back with ten contradictory principles. In a passionate speech, he defended the individual creative work of artisans and soundly rejected the notion of typification. In the ensuing debate, the majority voiced their support for van de Velde, including Walter Gropius. Muthesius had no choice but to concede defeat and retract his principles in their entirety.

The Bauhaus also kept its focus on craftsmanship in its early years. In 1923 Gropius finally announced a change of course. Until then, however, the debate on handcrafted versus industrial production was rehashed time and again.

Peter Behrens, AEG table fan for direct current, 1908 (design)

## Richard Riemerschmid

## Armchair from the
## Machine Furniture series, 1905 (design)

In 1903 Richard Riemerschmid began developing a revolutionary furniture series called *Maschinenmöbel* (Machine Furniture) for the Dresdner Werkstätten für Handwerkskunst (Dresden Workshops for Handicraft). Thanks to the largely mechanised and inexpensive production methods, the entire furniture set could be purchased at an affordable price – between 450 and 2,400 marks. Three series made from varying types of wood were produced for the living room, bedroom and kitchen, along with supplementary furniture. The furniture could be taken apart, easily transported, delivered in packages and reassembled by laypersons. Presented for the first time in 1905 in the magazine *Deutsche Kunst und Dekoration*, these pieces were among the highlights of the *Dritte Deutsche Kunst-gewerbeausstellung* (Third German Arts and Crafts Exhibition) in Dresden in 1906. All of the reports on the exhibition mentioned the machine room where the public could observe the manufacturing process. The furnishings initially referred to as 'Dresden home appliances' paved the way for industrial furniture production. KJ

# THE NEW WEIMAR
## An epilogue

THOMAS FÖHL

Henry van de Velde, Model for the Nietzsche monument in Weimar, 1912

**ON 10 FEBRUARY 1907**, Hofmarschall Aimé von Palézieux, Count Harry Kessler's arch-enemy at the Weimar court, died at the age of 63. Kessler had challenged him to a duel shortly beforehand. The rumour could not be quelled that Palézieux had taken his own life by poisoning, a fact that was subsequently verified. For Kessler, Palézieux's death drew a line under the New Weimar experiment once and for all. Nevertheless, he felt uneasy. Four days later he wrote to his friend, the poet Hugo von Hoffmannsthal: 'Compassion for him ... none. I would rather we had met with pistols, which would have been tidier than this grisly suburban drama ending. ... It is "beastly" in life that solutions are so often unsatisfying and messy, so seldom purifying and tragic; in pursuit of a clean sweep, one has ultimately only added to the dust.'

Any idea of looking to himself for possible causes did not cross Kessler's mind, however. He had challenged court society in Weimar as well as the Kaiser in Berlin and ignored and dismissed the likely consequences. Furthermore, in the years after 1904, he only stayed in Weimar sporadically for a few days or weeks at a time. He could (or would) only direct his innumerable projects from Berlin, London or Paris and even occasionally missed the openings of his exhibitions, which were mostly organised remotely from Paris. He had to delegate the administration to his secretary and the hanging in the museum to Henry van de Velde. He was largely bereft of a strategic response to the growing resistance in Weimar and to the intrigues against him personally. Accordingly, the complaints from Elisabeth Förster-Nietzsche and van de Velde stacked up. It must therefore be concluded that the failure of the New Weimar experiment was in no small part his own fault.

Thereafter, the Nietzsche-Archiv and the comfortable salons of Kessler and van de Velde remained the centre points of the established

Weimar circle. On the other hand, the intended broader public impact of the objectives it continued to pursue was inevitably overshadowed. Despite many setbacks, van de Velde designed a considerable number of private buildings in Chemnitz, Gera, Hagen, Hannover, Riga and Weimar; created opulent apartments; designed porcelains, ceramics and fabrics, elegant works in silver, jewellery, lamps and much more besides. Moreover, the 'all-round artist' was an eloquent and effective publicist of his lifelong campaign – his 'apostolate', as he called it – to establish 'his' New Style. Kessler, too, took up his pen as an art writer and went on to establish the Cranach Presse with great élan, which achieved worldwide success in the 1920s with its bibliophile publications.

Grand Duke Wilhelm Ernst had originally shown himself to be an open-minded regent who hoped that Kessler and van de Velde would give him direction and school his taste. In his exuberance following the successful appointment of van de Velde, the young Count Kessler had even compared the grand duke to a Renaissance prince and patron in Medici Florence. The parties had rapidly fallen out, however, and after Kessler's resignation, in July 1906, any dialogue had become impossible for the time being.

One final project – albeit reluctantly – linked the two hostile camps from 1911 to 1913. At the end of 1910, Elisabeth Förster-Nietzsche suggested commemorating her brother's seventieth birthday by erecting a monument to him in the garden of the Nietzsche-Archiv in 1914, and asked van de Velde to supply initial sketches. When Kessler learned of these ideas, he instantly took charge of the monument project. He established a committee of renowned representatives of the European cultural elite, acquired two interest-free loans, each in the amount of 20,000 marks, and purchased a site encompassing several hectares in the outskirts of Weimar. From a modest monument, a 'small temple' or 'Nietzsche grove', Kessler ultimately developed the vision of a 'Nietzsche stadium' for large-scale sporting events and festival performances in the spirit of the great thinker. Van de Velde had to work tirelessly on ever-changing new plans for the project, which in the end was estimated at more than one million marks. The grand duke was certainly receptive to

Military hospital in the Kunstgewerbeschule, *c.*1915–18. At the end of 1915 a home for soldiers was established in the former Kunstgewerbeschule, which had closed in summer 1915, and took over some of its furniture. Henry van de Velde had designed the dark stained chairs and the display cabinet, shown here filled with students' works, for his school.

the sporting element and, for the first time, signalled renewed interest in the New Weimar circle. He placed great faith in the 'goldmine' of the Nietzsche cult mentioned above, which had gradually become a formative influence on the character of his modest ducal seat. When the financing subsequently failed to materialise, Nietzsche's sister called all further activities to a halt in late 1913, burying the Nietzsche stadium.

Since their move to Weimar, in the spring of 1902, Henry van de Velde and his wife, Maria, were prey to constant animosities. None of their five children was baptised, and they were educated following anti-authoritarian principles. The van de Veldes, along with their widely derided collection of modern art, were considered exotic foreigners. Despite Kessler's departure, the courageous couple stayed on in Weimar. And after residing in two temporary homes, from 1908 they finally lived in their own Haus Hohe Pappeln, to the south of

Walter Gropius in his sergeant's uniform in the First World War, 1916

the city, in surroundings that were magically idyllic and loved by all. Yet this did nothing to stem the unrelenting attacks on the father of the family. Van de Velde had difficulties to contend with on all fronts and parried these with verve over the course of many years. But the final straw came when the grand duke went behind his back in 1913 and sought a new director for the Grossherzoglich Sächsische Kunstgewerbeschule Weimar (Grand Ducal School of Arts and Crafts) that van de Velde had built up. Despite various efforts by the Belgian, no consensus could be reached and the exasperated van de Velde quit his position in July 1914.

At the same time, he proposed his favoured candidate as successor for his position: the young and then little-known architect Walter Gropius, who considered the recommendation a great honour. Even during the war years, Gropius appeared in Weimar several times with the aim of securing the position. Then, amid the chaos of the early post-war months, the future prospects that emerged for Gropius in Weimar in 1919 were as wide open as those of his predecessor in 1902. He was able to take charge of van de Velde's art school complex as well as the two remaining intact workshops, one for bookbinding, run by Otto Dorfner, and the other for weaving, run by Helene Börner. Among the existing conditions that awaited Gropius in Weimar, we must not forget that – as result of van de Velde's progressive approach – he also inherited a long-standing, exemplary teaching method based on close cooperation between teachers and students as a team. Applied to the conditions of a new epoch, it would influence the Bauhaus until the end.

## Count Harry Kessler
## as an officer, 1915

From the end of the 1890s, Kessler's diary is full of entries about his military exercises as a reserve officer, his final rank being that of cavalry officer. Like millions of Germans, he went off to war with enthusiasm in August 1914 and initially condemned Henry van de Velde's steadfast pacifism on more than one occasion. In 1916 he was assigned to the German embassy in Bern, and during his time in Switzerland organised readings, concerts and an exhibition by the Deutsche Künstlerbund (Association of German Artists). After the war he was known as one of the most committed proponents of the League of Nations idea and battled on behalf of Germany's young democracy until his emigration, in 1933. TF

# THE 'BELGIAN BAUHAUS'

## A prospect of La Cambre

THOMAS FÖHL

Cristal Cochius, Design for the cover of the magazine *Revue ISAD*, 1931

**WALTER GROPIUS**, born in 1883, and Henry van de Velde, 20 years his senior, belonged to different generations. Even so, for recommending his successor and passing on the substance of his teaching, the Belgian art reformer may be considered the 'midwife of the Bauhaus'. One of the Bauhaus's maxims, 'art and technology – a new unity', was itself already implicit in van de Velde's credo. Since the 1890s he had firmly believed that 'art and handicraft' and a close cooperation with industry were indivisibly interlinked.

The First World War – the 'Great War' – brought traumatic experiences for both men. The young Berlin architect served on different fronts, while van de Velde, branded an 'enemy alien' after war broke out, suffered three years of utter denigration and depression.

'We have much to make good to you, dear professor,' Gropius penned in a letter to van de Velde, 'and as soon as the world's ears can discern finer tones than gunfire, some of us will be sure to stand up, give those fools short shrift and thank you in front of everyone for the gift you bestowed on our country.' The promise expressed by Gropius, on 1 December 1914, was never honoured. Van de Velde had no choice but to look elsewhere.

First, with the help of influential friends, van de Velde fled to Switzerland in April 1917, but could not send for his family to join him until the end of 1918. A project to establish a school and artists' colony in Uttwil, on the Swiss bank of Lake Constance, came to nothing, as did his plans for a monumental museum for the Kröller-Müller family. The new museum building had been planned since the beginning of the 1920s, near the Dutch town of Otterlo. It was first realised according to his plans, in drastically simplified form, beginning in 1936.

In 1925 a fourth chance for a new start opened up for van de Velde – initially as a complete surprise – in his home country. Thanks

to the help of old friends, he was appointed to a professorship for architecture and architectural theory at the University of Ghent. At first this position caused him considerable difficulties because in the intervening period he had almost forgotten how to speak his native language, Dutch. During the artist's childhood, as he himself emphasised in his memoire, *Geschichte meines Lebens* (Story of my life), he had thought of Flemish, or Belgian Dutch, as a 'dialect' spoken by workers, fishermen and farmers. He nonetheless mastered Dutch as a young person, although French remained – at least until the First World War – the language of the upper class in Flanders; van de Velde could express himself in it impeccably and wrote almost all of his letters, books and articles in French throughout his life.

Influential friends from the anarchist and socialist circles he had avidly frequented in the 1880s and 1890s paved the way for him to found his own college of design in 1926. Noteworthy individuals in this regard were Charles Lefébure, a close adviser to King Albert I of Belgium, and Camille Huysmans, who held the office of Minister of Culture at the time. As might be expected, the founding of the Institut Supérieure des Arts Décoratifs (ISAD) in the former convent of La Cambre in the outskirts of Brussels required an effort of considerable magnitude. Once van de Velde had drafted the statutes of his new college, which guaranteed him a maximum of independence as director with a minimum of control functions, there followed a heated parliamentary debate, accompanied by derogatory diatribes

Ernst Ludwig Kirchner,
*Henry van de Velde*, 1917

in the press about the 'Germanophile alien'. Nevertheless, the institution was formally established by royal decree on 30 November 1926. In addition to the subjects already taught in Weimar, by introducing a solid foundation course covering all material genres, he was able to expand the programme to include a host of other subjects, such as architecture, urban planning, typography, printing techniques, fashion and textile design, and theatre arts and practice.

During the 90-year history of its existence, the renowned school has boasted an abundance of illustrious teachers, including the architects Victor Bourgeois, Jean-Jules Eggericx, Huib Hoste, Louis H. De Koninck, Antoine Pompe and Léon Stynen; the sculptors Oscar Jespers and Willia Menzel; as well as the dancer and costume designer Marguerite Akarova; the painter Paul Delvaux and the book artist Micheline de Bellefroid. To this day, graduates of La Cambre represent an important segment of their country's cultural elite in the fields of architecture and the fine arts, design and fashion, theatre and dance, urban planning, media design, film and monument conservation.

Van de Velde successfully directed La Cambre until 1936, when he retired upon reaching the age of 73. Without skipping a beat, he immediately took on other official roles for the Belgian government. In 1947 he turned his back on his homeland once again, to settle in Switzerland one last time. He worked as an architect until the age of 90 and died in Zurich in 1957.

In founding his second school, van de Velde created a

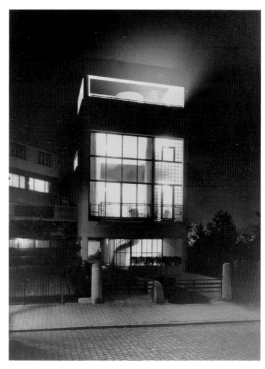

Paul-Amaury Michel, La Maison de Verre (House of Glass), 1933

new type of comprehensively oriented art and design college for Belgium from late 1926 on. Aware of the enormity of the developmental task, he saw this monastic-style refuge with reference to his school of arts and crafts, the Grossherzoglich Sächsische Kunstgewerbeschule, in Weimar as his second 'citadel of modernism', on an equal footing with the Bauhaus of his successor Walter Gropius. Although the National Socialists shut down the Bauhaus for good, in 1933, the fascists did not succeed in burying its legendary reputation – quite the opposite. Gropius, Ludwig Mies van de Rohe, Georg Muche and many other Bauhaus masters and students, for want of commissions and in part also due to their Jewish ancestry, were relatively quick to emigrate. In the United States, as 'heroes of modernism' they brought the influential ideas of the Bauhaus to maturity, consistently operating as more effective and professional propagandists than van de Velde had ever been.

By contrast, van de Velde's La Cambre, 'le Bauhaus Belge', has successfully endured up to the present and will celebrate its hundredth anniversary in a few years' time. That will surely give occasion to pay appropriate tribute to La Cambre as the still-vital 'Belgian Bauhaus', just as the centenary of the Bauhaus is being commemorated in 2019.

Akarova, Costume for the dance work
*Le choeur de l'Orestie* by Darius Milhaud, 1931 (design)

## Teaching staff and assistants of the Institut supérieur des arts décoratifs in the courtyard of La Cambre, Brussels, 1928

After King Albert I of Belgium had issued the founding decree on 30 November 1926, the teaching staff and assistants of the Institut supérieur des arts décoratifs assembled in the courtyard of La Cambre in 1928. In this setting 63 individuals were immortalised, including 28 mostly quite young women. For the sake of a complete overview, the extra-wide horizontal format of the photograph had to be cropped down to its centre. The extract shows the founding director, Henry

van de Velde, with arms folded, and on the left, wearing spectacles and with his hands in his pockets, Herman Teirlinck, van de Velde's successor from 1936 onwards. The critic, Germanist, dramaturge and author taught theatre practice and theory from 1927 to 1946 and held the post of director at La Cambre until 1950. His daughter Leentje married Thylbert (Thyl) van de Velde, the only son of the school's founder, in 1929. TF

# THE BOOK ARTIST AND TEACHER OTTO DORFNER

## Between Henry van de Velde, the Bauhaus and Goethe's *Faust*

THOMAS FÖHL

Henry van de Velde,
Selection of utility bindings
he designed for his
long-standing customers
Curt Herrmann and
Dr. Alfred Wolff, executed
by the bookbinding
workshop at the Kunst-
gewerbeschule, c.1910

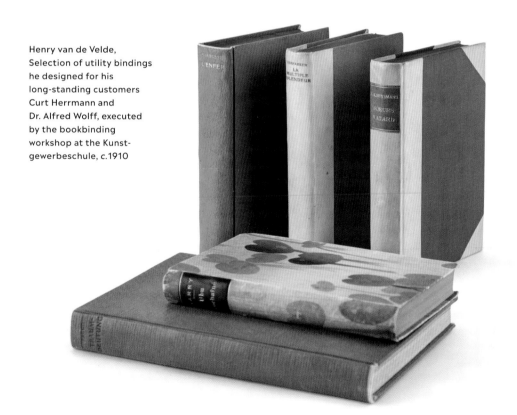

**BORN IN SWABIA IN 1885** into an affluent family, Otto Dorfner began learning his trade as a bookbinder in his hometown of Kirchheim unter Teck. After passing his master craftsman examination in Meiningen, he enrolled at a vocational school operated by the renowned book artist Paul Kersten in Berlin in 1908. There, he studied script handwriting under Ludwig Sütterlin and gained further expertise in gilding. At Kersten's recommendation, he was granted a position at the Grossherzoglich Sächsische Kunstgewerbeschule (Grand Ducal Saxon School of Arts and Crafts), headed by Henry van de Velde, in Weimar in 1910.

From these modest beginnings, the young bookbinding master quickly built a department which saw extraordinarily positive growth as an instructive and productive workshop. The School of Arts and Crafts was forced to finance half of its operating budget alone, and Dorfner's department contributed the greatest share by far.

Van de Velde announced his resignation in July 1914 but continued to run the school for another two semesters until it was dissolved, on 1 October 1915. Dorfner, however, was able to continue operating his department privately as the Staatlich unterstützte Fachschule für kunstgewerbliche Buchbinderei (State-supported Technical School for Artisanal Bookbinding). In April 1918 he purchased the workshop's entire inventory, including most of the book-gilding stamps, tools and all of the machines. One year later, Walter Gropius reinstated Dorfner in his former function, at the Bauhaus. In 1922 Dorfner resigned and started his own business but continued teaching a number of his former Bauhaus students. He maintained close personal ties with them as substantiated by more than one hundred artworks which Dorfner had purchased from the *Bauhäusler*.

During his time at the Kunstgewerbeschule and the early Bauhaus, Otto Dorfner adopted various ideas that evidently reflect the

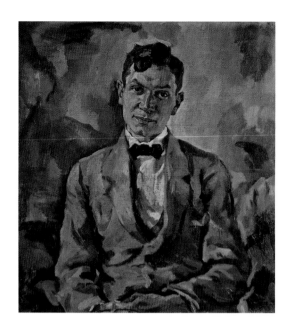

Franz Heffels,
*Portrait of Otto
Dorfner*, 1919

influence van de Velde and certain Bauhaus masters had on him.
These borrowed stylistic elements were only used episodically, how-
ever. An overview of his diverse oeuvre spanning five decades reveals
a distinctive and unmistakable style by a book and script artist who
primarily applied linear ornamentation and exhibited mastery in
typeface and book sheet design. The indivisible union of art and
the crafts remained Dorfner's lifelong credo, the same conviction
embraced by van de Velde since the 1890s and propagated in slightly
modified form by the Bauhaus in 1919. Due to this attitude, it was
understandable that Count Harry Kessler – who, as an intellectual,
completely ignored the Weimar Bauhaus – contracted Dorfner to
bind several luxurious volumes printed by his own Cranach Presse.

Dorfner deserves recognition as one of the most influential
book artists of the twentieth century; until 1955 he had trained over
500 bookbinders at his technical school. Privately he had a passion
for bibliophile prints and Johann Wolfgang von Goethe's opus mag-
num *Faust*, which he repeatedly reinterpreted in some 200 bind-
ings for his own collection. This is impressively demonstrated by his
'book shrine' for the 143-volume 'Sophie edition' of Goethe's works,

Otto Dorfner, Binding for the programme Weimar State College of Architecture: Structure and Purpose, 1927. For this publication, Otto Bartning additionally entrusted the complete typography to Dorfner.

which was constructed four times between 1949 and 1953, and whose bindings took about one year to produce. Dorfner's estate contains about 20 sketches of the bookcase. During these early years of the German Democratic Republic, this example of *Prachtmöbel* (magnificent furniture) formed a peculiar bridge between the Neoclassical style of the Hitler and Stalin years and the era of Weimar Classicism. The shrine is also a reflection of how the young East German state used the commemorative festivities marking Goethe's 200th anniversary to legitimise its status as a self-confident cultural nation.

After Dorfner's death, in 1955, it was uncertain what would become of the workshop. Dorfner had trained his son Günter, born in 1919, to take over the business, but the latter died on the battlefield in the Second World War. His other son, Hans Werner, born in 1913, had studied to become a doctor, but took over the workshop instead. From 1946 to 1950, he enrolled in a second-degree programme in Leipzig as a certified graphic designer. Parallel to his studies, he received on-the-job training as a bookbinder in his father's workshop and took typography courses at the Hochschule für Architektur und Bauwesen Weimar (Weimar College of Architecture and Civil Engineering). Despite his efforts, he eventually realised he would never be able to meet his father's high standards in the long term. Consequently, he leased the workshop to the Hochschule für Graphik und Buchkunst (Academy of Fine Arts) in Leipzig in 1957. In 1968 he was forced to sell a large parcel of the property for a ridiculously low price to the academy, which used the land to construct a new building. By 1974, after enduring constant pressure from the public authorities, Hans Werner Dorfner submitted to selling the two-family house, workshop and business premises at Erfurt Strasse 8 to the East German Ministry of Culture. The estimated purchase price was reduced again by a third to 80,000 marks and paid out in annual instalments until his death, in 1989. This did not include, however, the extraordinary collection of more than 2,000 gilding stamps that the Ministry of Culture classified as a 'national cultural treasure' and purchased for an additional 10,000 marks. The agglomeration of workshop equipment and materials, including all of its tools, machines and extensive supplies of leather and coloured

Otto Dorfner, Binding for Giovanni Boccaccio, *Das Dekameron*, 1928

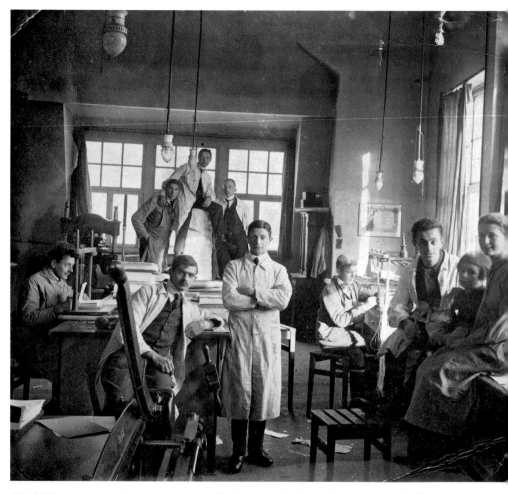

Otto Dorfner surrounded by students and staff in Henry van de Velde's former director's office at the Kunstgewerbeschule, Weimar, c.1920

paper that remained at the time the workshop closed, in 2011, was ultimately accepted as a donation from the Dorfner family.

In 1978, the Burg Giebichenstein Kunsthochschule Halle (University of Art and Design Halle), took over the Otto-Dorfner-Werkstatt (Otto Dorfner Workshop) for the purpose of training students. The university allowed students to reside in the Weimar workshop building for a period of at least two semesters. German reunification in 1990 marked a new chapter for the workshop, which resulted in a long-lasting dispute spanning over 25 years about the future status

and continued existence of what was now a designated historical landmark. Without any progress in securing a future sponsor, the discussion often focused on founding a museum on the site. The book artist Mechthild Lobisch, who received a professorship in Halle in 1995, founded the Otto Dorfner-Institut zur Erforschung der deutschen Einbandkunst (Otto Dorfner Institute for the Study of German Bookbinding Art) in 1997, and in 1999, organised an exhibition on Dorfner's oeuvre with an extensive accompanying catalogue.

Unfortunately, Lobisch's efforts proved unsuccessful, and the workshop was shuttered in 2011. In 2017, negotiations between Halle and the Klassik Stiftung Weimar resulted in an agreement to transfer the Otto-Dorfner-Werkstatt, with an inventory count of over 5,000, to Weimar as a permanent loan. The Klassik Stiftung continues to pursue the goal of displaying the collection in the Neue Museum on a permanent basis with the prospect of acquiring ownership of the workshop in the future.

After occasionally difficult but friendly negotiations, the practically intact workshop has returned to Weimar for the long term and – after receiving additional items from Halle – can now be displayed at a historical site, namely in its original context of van de Velde's Kunstgewerbeschule. Such an outcome is incredibly fortunate for an institution which has written over 100 years of cultural history – and that over the course of five governmental systems since its establishment in 1910.

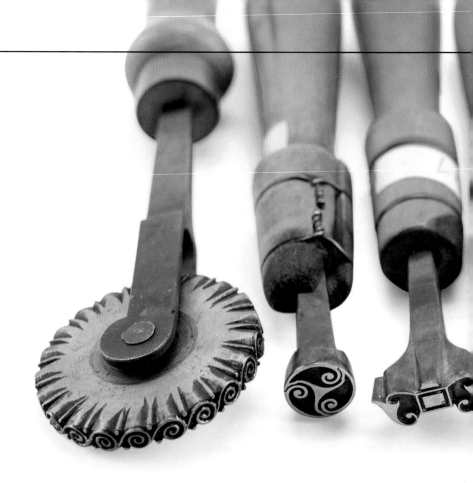

## Rolling stamp and embossing stamps from the Dorfner workshop in Weimar, c.1920

This small selection of seven embossing stamps and a rolling stamp from the Dorfner-Werkstatt from the 1920s illustrates in part Henry van de Velde's influence. These stamps were used often as one can guess from their charred shafts secured with wire clamps. The third stamp from the right, based on a design by Edward

Gordon Craig, was exclusively reserved for the red morocco bindings of William Shakespeare's *Hamlet* printed by Count Harry Kessler's Cranach Presse. On the right is Dorfner's signature stamp, which he always imprinted on the lower edge of the back cover. TF

Initials at the end of the highlighted object texts refer to the following authors,
listed in order of appearance in the present volume:

KJ    Kilian Jost, Research Associate, Neues Museum Weimar

GW    Gerda Wendermann, Curator of Paintings 1860–1919

UB    Ulrike Bestgen, Bauhaus Museum Head of Department, Modern and Contemporary Art

TF    Thomas Föhl, Special Representative of the President

SW    Sabine Walter, Curator of the Arts and Crafts of the late 19th and early 20th centuries

AN    Antje Neumann, Research Assistant, Henry van de Velde catalogue

MU    Martina Ullrich, Research Volunteer, Neues Museum Weimar and Bauhaus Museum

# ACKNOWLEDGEMENTS

WE ARE GRATEFUL TO THE FOLLOWING ORGANISATIONS AND
INDIVIDUALS FOR THEIR SUPPORT OF OUR EXHIBITION:

Altenburg: Arboreus GmbH

Bad Berka: Steinmetz Erdmann, ThILLM
(Ulrich Mittelstedt, Rigobert Moellers)

Bad Tabarz: Ingenieurbüro THOMSEI

Barcelona: Jens Kauth

Basel: Serge Mauduit

Berlin: René Arnold, Aurelia Badde, Bildgiesserei
Hermann Noack GmbH & Co KG, Dr Kerstin
Decker, Georg Kolbe Museum (Dr Julia Wallner),
Manfred Ludewig, Deborah Shannon, Tactile
Studio, Vertretung der Deutschsprachigen
Gemeinschaft, der Wallonie und der Föderation
Wallonie-Brüssel, Belgische Botschaft (Alexander
Homann, Nicole Ackermann), Cornelia Vossen

Brussels: L'École nationale supérieure des arts
visuels (ENSAV) de La Cambre (Benoît Hennaut,
Régine Carpentier)

Bürgel: Keramik-Museum Bürgel (Konrad Kessler)

Cologne: Freund und Kühler (Monika Nürnberg),
Restauratorinnen-Partnerschaft Beier, Dr Joann
Skrypzak-Davidsmeyer

Ditzingen: Philipp Reclam jun. GmbH & Co. KG
(Dr Karl-Heinz Fallbacher )

Dresden: hasenkamp Internationale Trans-
porte GmbH, whitebox GbR (Daniel Sommer,
Christian Frommelt)

Dülmen: Simone Püttmann

Düsseldorf: Jörg Nowack, Dr Helmut Reuter,
Hans-Peter Roger

Eisenach: Corina Schmidt, Wartburg-Stiftung
Eisenach (Günter Schuchardt, Grit Jacobs)

Erfurt: Büro & Praxis für Metallrestaurierung
Prof. Bernhard Mai, Koordinierungsstelle
Barrierefreiheit (Sabine Feuer and Markus Reb-
stock), Kummer Lubk + Partner (Markus Sabel),
Andreas Manigk, Nüthen Restaurierungen,
Thüringer Staatskanzlei/State Chancellery of
Thuringia (Dr Marita Kasper, Daniela Lasserre,
Anke Wollweber), Thuringian State Office for
Heritage Management and Archaeology (Knut
Reichel), Thomas Wurm Metallrestaurator

Frankenberg an der Eder: Helen Thonet

Frederikshavn: Roblon Lighting

Frohburg: Matthias Krahnstöver

Garmisch-Partenkirchen: Prof. Dr Stephan Wolff,
Ulrike Wolff

Gera: Karsten Skwierawski

Gotha: KUBO GmbH

Halle an der Saale: Burg Giebichenstein Univer-
sity of Art and Design, Halle (Janosch Kaden,
Dr Sandra König, Edda Nitschke, Syrta Traub),
Kulturstiftung des Bundes (Friederike Zobel),
Wolfgang Stockert

Hamburg: grauwert. Büro für Inklusion & demo-
grafiefeste Lösungen (Matthias Knigge), Museum
für Kunst und Gewerbe Hamburg (Prof. Dr Sabine
Schulze, Dr Caroline Schröder), Günther Thieme,
Guenther Wulff

Helmstedt: Paramentenwerkstatt der von Veltheim-Stiftung und Textil-Restaurierung beim Kloster St Marienberg in Helmstedt

Karlsruhe: NoBLå – Raumkonzepte & Gestaltung

Krefeld: Deutsches Textilmuseum/German Textile Museum, Space Interactive

Kreuzebra: Kruse Restaurierungen

Kromsdorf: Rühling Shop + Objekte

Langenhagen: Expomondo by Holtmann GmbH + Co.KG

Lauterbach: Claus Laemmle

Leipzig: ALEXA-Audioproduktion, Fissler & Kollegen, Hirmer Verlag (Kerstin Ludolph), Heidi Stecker, Ole Teubner

London: Lucilla Herrmann, HH Princess Leonie of Saxony-Weimar-Eisenach

Manchester: Paul Herrmann

Mannheim: HRH Prince Michael of Saxony-Weimar Eisenach

Melbeck: Werkstatt für Buch und Kunst (Ireen Kranz)

Mellingen: Lytec GmbH

Mühlhausen: Restaurierung Sven Bodewald

Munich: Ernst von Siemens Kunststiftung (Dr Martin Hoernes), Hirmer Verlag (Ann-Christin Fürbass, Peter Grassinger), Wolf D. Pecher

Münster: Hans-Dieter Rieder, Heidrun Rieder

Penrhos, Wales: Prof. Dr Georgina Herrmann

Potsdam: MicroMovie Media GmbH

Rabenau: Stuhlbau & Restaurierungen Christian Hick

Reken: Heddier electronic GmbH

Schalksmühle: Hoffmeister Leuchten GmbH

Thurnau: Volker Illigmann

Titisee-Neustadt: Robert Brambeer

Vaduz: Curt Herrmann Heritage Foundation

Weimar: Atelier Papenfuss (John Mitsching), 'Bauhaus Agents' schools, Bauhaus-Universität Weimar (Prof. Andreas Kästner), Bauhaus-Universität Weimar, Modernist Archive (Dr Christiane Wolf), Alexander Burzik, Beate Dorfner-Erbs, Einrichtungshaus Kneisz, Heinzz Flottran, Fotoatelier Louis Held, g3-Plan (Ralf Grubba), Glas-Köhler, Renate Hausotte-Götz, Peter, Paulina and Julius Heckwolf, Dr Norbert Korrek, Gaby Kosa, Ernst Kraus, Marx Krontal Partner (Dr Cora Pischke), Ria Radicke, Wolfgang Schitke, Reiner Schlichting, Stadt Weimar, Abt. Denkmalschutz/City of Weimar Monument Conservation Unit (Klaus Jestaedt), Stadtmuseum (City Museum) Weimar (Dr Alf Rössner), Tischlerei Thormeyer, Unikat-Hentrich, Jens Weber and Andreas Wolter, Weimarer Kunstgesellschaft e.V.

Woodham Walter, Essex: Patricia Herrmann

# IMAGE CREDITS

# NIETZSCHE, VAN DE VELDE AND MODERNISM AROUND 1900

Neues Museum Weimar
from 6 April 2019
An exhibition organised by the Klassik Stiftung Weimar
www.klassik-stiftung.de

Die Beauftragte der Bundesregierung
für Kultur und Medien

Freistaat Thüringen — Staatskanzlei

weimar
**Kulturstadt Europas**

**Sponsored by**

EFRE
EUROPA FÜR THÜRINGEN
EUROPÄISCHER FONDS FÜR REGIONALE ENTWICKLUNG | EUROPÄISCHE UNION

Wallonie - Bruxelles
International.be
Délégation Berlin

## EXHIBITION

**Curators** Sabine Walter, Kilian Jost, Gerda Wendermann, Martina Ullrich
**Project lead** Ulrike Bestgen, Sabine Walter
**Consulting** Thomas Föhl, Norbert Korrek, Claus Laemmle, Antje Neumann, Helmut Reuter, Frank Sellinat, Susanne Wenzel, Stefan Wolff
**Exhibition design and graphics** whitebox, Dresden
**Werkcafé design** NoBLå – Raumkonzepte & Gestaltung, Karlsruhe
**Education** Regina Cosenza Arango, Maxie Götze, Laura Meinhardt, Johannes Siebler, Valerie Stephani, whitebox, Dresden
**Media collages** Kilian Jost, Martina Ullrich
**Media** Space Interactive, Krefeld
**Conservation** Diana Eicker, Uwe Golle, Konrad Katzer, Anne Levin, Alexander Methfessel, Laura Petzold, Katharina Popov-Sellinat, Carsten Wintermann
**Project research assistant** Sabine Küssner
**Exhibition architecture** Holtmann GmbH+Co.KG, Langenhagen; Rühling Shop + Objekt, Kromsdorf
**Exhibition installation** Ellen Bierwisch, Olaf Brusdeylins, Nico Lorenz, Uwe Seeber, Karsten Sigmund, Sabine Thierolf, Mike Tschirschnitz, Timmy Ukat; Fissler & Kollegen GmbH, Leipzig
**Logistics of objects** Michael Oertel, Robert Steiner
**Finance** Franka Günther, Stefanie Landgraf, Sabine Walter
**Issuing authority/Budget** Hans-Jürgen Assmann, Ulrike Glatz, Thomas Lessmann, Nency Lorenz, Anke Schmidt, Sandra Schöppe
**Marketing** Rainer Engelhardt, Daniel Clemens, Andrea Dietrich, Toska Grabowski, Melanie Kleinod, Antje Puschke, Ulrike Richter, Manuela Wege
**Public relations** Franz Löbling, Timm Schulze
**Security** Janine Schaller, Alexander Stelzer
**Monument conservation** Ulrich Brucksch, Susanne Dieckmann, Ulrike Glaser, Johann Philipp Jung

PUBLICATION

**Editors** Sabine Walter, Thomas Föhl,
Wolfgang Holler
**Authors** Ulrike Bestgen, Thomas Föhl, Wolfgang
Holler, Kilian Jost, Antje Neumann, Martina Ullrich,
Sabine Walter, Gerda Wendermann
**Copy-editing/Proofreading** Joann Skrypzak-
Davidsmeyer, Cologne
**Image editing** Heidi Stecker, Leipzig
**Translations** Deborah Shannon, Berlin;
Robert Brambeer, Titisee-Neustadt
**Project lead, Hirmer Verlag** Kerstin Ludolph
**Project management, Hirmer Verlag**
Ann-Christin Fürbass
**Design and typesetting** Academic Publishing
Service Gunnar Musan
**Pre-press** ReprolineGenceller, Munich
**Paper** Gardamatt Art
**Typefaces** Chronicle Text, Madera
**Printing and binding** Westermann Druck,
Zwickau

© 2019 Klassik Stiftung Weimar;
Hirmer Verlag GmbH, Munich; and the authors
www.hirmerverlag.de

ISBN 978-3-7774-3278-6 (English edition)

ISBN 978-3-7774-3277-9 (German edition)

**Cover, front** Henry van de Velde, Armchair, 1897,
permanent loan from the Ernst von Siemens
Kunststiftung
**Cover, back** Henry van de Velde, Vase, 1902,
permanent loan from a private collection,
Düsseldorf (see p. 90)
**Frontispiece** Henry van de Velde, Design
for the modification of the Grossherzogliche
Museum Weimar, director's office, 1908,
Klassik Stiftung Weimar

**Bibliographic information from the German
National Library** The German National Library
registers this publication in the German National
Bibliography; detailed bibliographic data is
available at http://www.dnb.de.